The Art Institute of Chicago Museum Studies

VOLUME 13, NO. 1

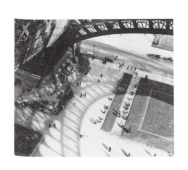
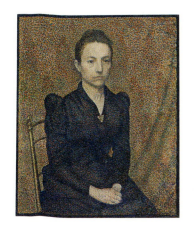
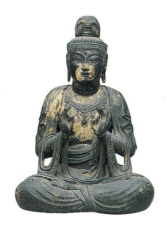

The Art Institute of Chicago Museum Studies

VOLUME 13, NO. 1

ISSN 0069-3235
ISBN 0-226-02811-9

Published by The Art Institute of Chicago, Michigan Avenue at Adams Street, Chicago, IL 60603. Distributed by The University of Chicago Press, Journals Division, P.O. Box 37005, Chicago, IL 60637. Regular subscription rates: $12 for members of the Art Institute, $16 for other individuals, and $25 for institutions. All back issues are available from The Art Institute of Chicago, Museum Shop, and The University of Chicago Press: Single copies are $8.50 for individuals and $13 for institutions. Single copy price for vol. 12, no. 2 is $12.95 for individuals and $19.50 for institutions.

Editor of *Museum Studies*: Susan F. Rossen; Assistant Editor: Elizabeth A. Pratt; Designer: Betty Binns Graphics, New York.

Cover: Detail of Figure 14, page 17. Back cover: Figure 15, page 17.

Photo credits: Unless otherwise indicated, all photographs have been taken by the Art Institute's Department of Photographic Services.

6,000 copies of volume 13, no. 1 were typeset in Stempel Garamond by Trufont Typographers, Hicksville, NY, and printed on 70lb. Frostbrite Matte by American Printers and Lithographers, Chicago, IL.

The Art Institute of Chicago Museum Studies is published through the generosity of the Sterling Morton Charitable Trust, with additional support from the Mellon Foundation endowment for scholarly publications income and the Paul and Gabriella Rosenbaum Foundation.

Preface

One of the goals of *The Art Institute of Chicago Museum Studies* is to provide the reader with a selection of articles representing each of the museum's curatorial departments in order to reflect the depth and range of the collections. In this issue, in addition to two articles on works in our nineteeth-century European collection, we are very pleased to include three articles on areas of the permanent collection—photography, oriental art, and arms and armor—being featured in the journal for the first time since its revival in 1984.

Possessing one of the finest holdings of photography in any American museum, the Department of Photography is particularly rich in the work of an exceptional group of international photographers and photojournalists working in Paris in the 1920s. Central among the plethora of motifs and stimuli available to them there was the monument that had become totally identified with that great and vital city, as well as with the modern age—the Eiffel Tower. In an eloquent and evocative study, Curator David Travis considers a selection of photographs of the tower made during those heady days by French, German, and Hungarian photographers. Despite the varying interests and intents of these artists, the images, taken together, reflect their excitement in exploring the camera's expressive potential before a symbol whose structure, spaces, height, and shadow carry so much meaning.

Many Chicagoans are now familiar with Japan's first state Buddhist center, Tōdai-ji, after the major exhibition of many of its treasures seen at the Art Institute in 1986. At Tōdai-ji, in the mid-eighth century, an elaborate system of workshops was set up to construct in a very short period of time an extensive complex of temples and attendant buildings. In the sculpture workshop, a gifted group of artists produced a body of work by refining techniques of wood carving and dry-lacquer finish as they evolved a new vocabulary of forms based on Chinese prototypes. In a fascinating article that makes very clear a complex and, for most westerners, unfamiliar topic, Samuel C. Morse, Assistant Professor of Art History, Amherst College, traces the development of these new processes and styles as artists at Tōdai-ji established for the first time a tradition of Japanese monumental religious sculpture. The occasion for this article is the presence in the Art Institute of a fine and rare seated Bodhisattva, the only sculpture dating from the early years of the Tōdai-ji workshop found in a collection outside Japan.

In 1984, the Art Institute acquired the extensive collection of arms and armor of Chicagoan George F. Harding, Jr., and became one of the leading repositories of this kind of object in America. The collection is introduced to readers of this issue in an article devoted to one of its most outstanding pieces, an elaborately decorated wheellock pistol that was once owned by King Louis XIII of France. In his examination of the pistol, Leonid Tarrasuk, Consulting Curator of Arms and Armor, discusses the pistol's fascinating history, the formation of the French royal collection of arms and armor, and the specialized industry that produced such superbly crafted and technically advanced pieces that were so highly prized by Europe's ruling classes.

The two articles on paintings from the museum's nineteenth-century European collection appear at a time when both are on view, after long absences, in the Art Institute's newly refurbished galleries of European art. We are very pleased to be able to include a study by Robert L. Herbert, Professor of Art History at Yale University, on a work by the leading French Realist painter Gustave Courbet. Mr. Herbert connects this painting of a lusty café proprietress, Mère Grégoire, with a popular song and the leftist politics of the French lyricist Pierre Jean Béranger. The painting thus reflects not only the urban milieu of a café in which food and companionship could be had, but also a period of great social ferment, in which working-class cafés like Mère Grégoire's played a significant role in spreading ideas and solidifying public opinion.

Some thirty years after Courbet painted *Mère Grégoire*, Georges Seurat exhibited his signal picture about the weekend recreation of Paris's middle and working classes, the Art Institute's *Sunday Afternoon on the Island of La Grande Jatte*. This painting had a profound effect on the subsequent development of European art more for its innovative technique, which Seurat called "Scientific Impressionism," than for its theme. Seurat's influence on Belgian artists, and one in particular—Georges Lemmen—is the focus of an article by Jane Block of Princeton University which highlights a haunting portrait of the young artist's sister, Julie, executed in this radical new style.

In the next issue of *Museum Studies*, we focus again on a special area of the Art Institute's collections, in celebration of the Burnham Library of Architecture's seventy-fifth anniversary. Established in 1912 after the death of Daniel H. Burnham, the renowned Chicago architect, the Library's rich and varied holdings are the subject of several articles: on a collection of books belonging to the office of French Neoclassical architects Charles Percier and Pierre Fontaine, by David van Zanten, professor of art history at Northwestern University; on a rare collection of Louis Sullivan's manuscripts, by Robert Twombley, author of the most recent book about Sullivan; on the Library's holdings of architectural photography, by Richard Pare, Curator of Photography at the Canadian Centre for Architecture, Montreal; and a look at Burnham himself, by Ross Miller of Trinity College. Also included will be the history of the library by Mary Woolever, Architectural Librarian at the Ryerson and Burnham Libraries, and a photo-essay of highlights of the Library's collection assembled by John Zukowsky, Curator of Architecture, and Susan Godlewski, Associate Director of the Libraries. This special commemorative issue will be generously illustrated.

SUSAN F. ROSSEN, *Editor*

3

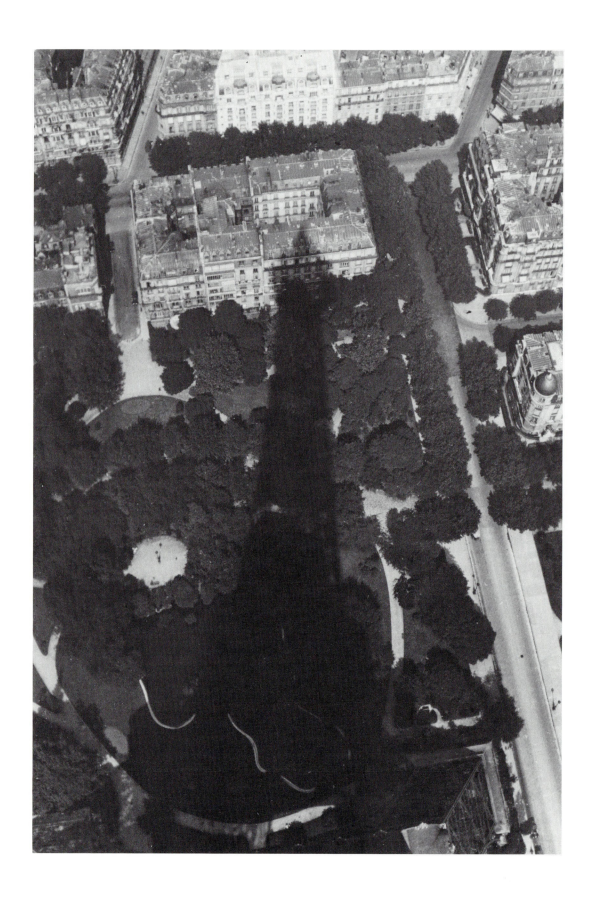

In and Of the Eiffel Tower

DAVID TRAVIS, *Curator of Photography*

*E*VERY day that the sun shines, an ethereal shadow slips through Passy, bridges the Seine, and passes across the façades along the allée de Paul Deschanel. If it comes, it is punctual. Toward evening, it reaches across Paris and laces her to the earth, dissipating with the sun in the last moments of its daily sweep. The shadow is cast by the Eiffel Tower, which guards and commands the city like no other monument, like no other piece of her geography. Its watch is irresistible and steady.

The year Germaine Krull (French, 1897–1985) photographed the shadow of the Eiffel Tower stretching across the tree tops beneath it may have been 1925, 1926, or 1927; one cannot tell from the picture (fig. 1). Its details are of a different order of precision. The angle of the shadow east of due north would allow one to calculate the time of the afternoon to the hour, as its length would allow one to determine the season of the year to the month, if it mattered. These, however, are the mislead-ing clues and inadvertent pieces of information that are often unusually clear in photographs; the photographer's original intentions, on the other hand, are seldom so easily discerned.

When Krull made this photograph, she was just at the beginning of her fame as a photographer. As a girl, she had grown up in Paris. However, the semi-abstract pho-tographs of iron structures for which she first became known are not particularly French in character, perhaps because her German mother had separated from her French father around 1909 and had taken her at the age of twelve to Munich. There, she was later instructed in photography. By 1919, she set up her first studio in Munich, only to establish another the following year in Berlin. In 1921, she moved to Holland for three years and then returned, in 1924, to a Paris now teeming with artists, who began accepting photographers around their café tables in Montparnasse.

At the time the shadow photograph was made, Krull was completing a photographic series of industrial struc-tures and machines, which she had begun in Amsterdam and Rotterdam, and which was to comprise a portfolio entitled *Métal*.[1] This photograph would not be included since its subject was Paris and the tower, not metal and machines. Furthermore, the abundant foliage flocking the ground made it, by comparison, scenic. In May

FIGURE 1. Germaine Krull (French, 1897–1985). *Champ de Mars*, 1925/27. Silver-gelatin print; 22.3 × 15.2 cm. The Art In-stitute of Chicago, Photography Purchase Account (1984.152).

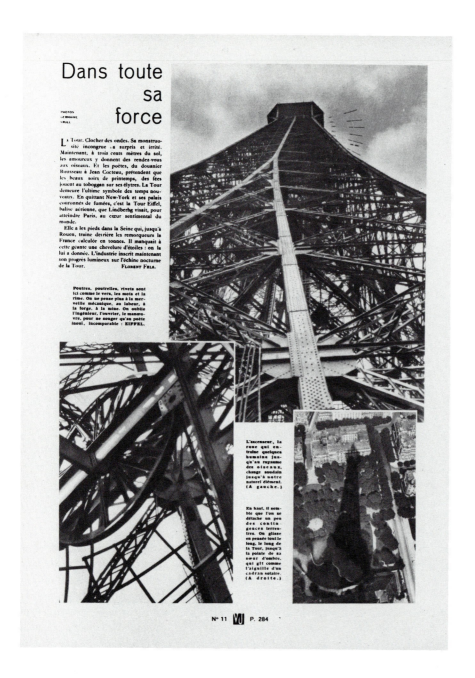

FIGURE 2. Page 284 from *Vu* 11 (May 30, 1928), with halftone reproductions of photographs by Germaine Krull and text by Florent Fels.

1928, it appeared in the eleventh issue of the illustrated magazine *Vu*, along with two others of the tower from *Métal*, in a one-page picture article (fig. 2). The publisher of the new venture, Lucien Vogel, had commissioned Krull as early as 1927 to photograph the tower after having seen some of her photographs of iron structures. This photograph could have been taken at that time. Florent Fels, the critic, writer, and publisher of the magazine *L'Art vivant* was even more enthusiastic about Krull's work and wrote the short accompanying text and three captions celebrating the tower with an overtly modern sensibility.[2] The caption to this photograph reads: "From above, it appears that one disengages a bit from terrestrial contingencies. One glides in thought along the length of the tower right up to the point of her sister the shadow which lies like the stylus of a sundial." For Fels, the tower was not the hermaphroditic mystery that his casual juxtaposition of a masculine image with the term "sister" might suggest, but simply "the supreme symbol of the new era." In speaking for Krull's

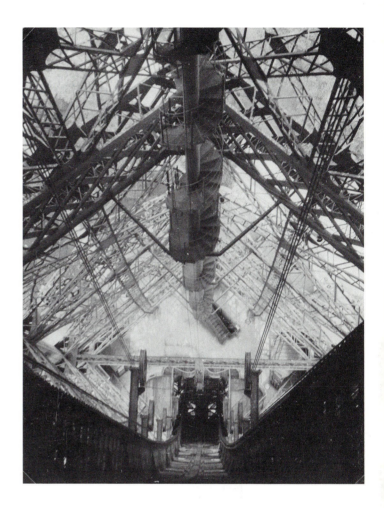

FIGURE 3. Germaine Krull. *Eiffel Tower, elevator track and staircase*, silver-gelatin print; 20.7 × 16.2 cm. Chicago, Edwyn Houk Gallery.

intentions, Fels transformed, as well, the hard, iron components of Eiffel's calculations by insisting that "the girders, beams, and rivets are like verse, word, and rhyme." The tower is no longer a wonder of engineering or construction, although it was still the world's tallest structure, but an unheard-of marvel of poetry. But, if Fels's ebullient verbiage parallels Krull's bold geometries, his persuasive confidence makes it more difficult to decide exactly how *she* felt about the photograph of the shadow. It is the smallest in the layout. Perhaps, she would have rather done without it. The largest is considerably more assertive, to the point of being phallic, and the third almost militant in its mechanical trenchancy. In comparison, the shadow photograph is unimposing, proclaiming equivocally either that progress situates technology and engineering over art and architecture, or that art and architecture are what is left after each round of progress has passed. Despite such subtle interpretations, whether intended or not, the shadow in the rotogravure reproduction was made darker than in the original photograph, causing it to jut out over Paris rather than being part of her. It was the tower that dominated the city, less with the grace of feminine charm than with the supremacy of masculine rule, much like the character of Krull's own photography. The result of the printing and the unambiguous text was a new kind of journalism—a photographer's page in which an editor's garnish forces to the surface *one* interpretation out of the several possibilities the photographs may contain.

At first, the tower did not appeal to Krull in the way iron bridges or harbor cranes had. She thought it a "lifeless, black monstrosity" and old, not at all modern.[3] In taking the elevators from one platform to another, she found few details of which she could make anything. Only when she discovered a little-used staircase at its innermost passage of ascent, next to the elevator cables, was she able to make the kind of photographs that would later be considered for inclusion in the *Métal* portfolio (figs. 3, 4). "Everything came to life and had nothing to do with the Eiffel Tower as we had known it: iron lives!"[4] For Krull, it became a structure abstracted from time, place, and purpose. Judging from the final layout

in contrast with its text, however, it seems that Vogel or an art director must have realized that for the readers of *Vu* it was necessary to have at least one photograph showing the tower as part of Paris, if only as a shadow.

The fortieth anniversary of the tower's completion would not be for another full year; *Vu*'s publication of Krull's photographs started the celebration early. Actually, a long series of imaginative celebrations had taken place since the tower's construction. Declared vulgar, if not hideous, by a handful of influential tastemakers when its construction began in 1887, the gargantuan tower two decades later had become a primary object of inspiration to a generation of avant-garde painters, poets, architects, filmmakers, and even historians seeking symbols of the new spirit of their age.[5] Surviving the scrutiny of the most talented and inventive minds, it served as the nominal subject of several of their projects: from 1909 to 1911, it was the dominant subject of the paintings of Robert Delaunay (French, 1885–1941).[6] It

7

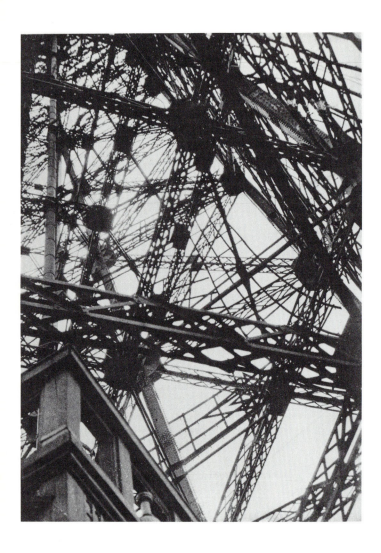

FIGURE 4. Germaine Krull. Plate no. 11 from *Métal*, a portfolio of sixty-four photographs printed in collotype (Paris, A. Calavas, n.d.). The Art Institute of Chicago, The Ryerson Library, Mary Reynolds Collection.

across the atmosphere things flow. . . . They lose their delineated forms orbiting below, mixing one with another."[9] The discrepancies between nature and the spare structure of its representation or analogies between perceptual experience and the artificial life created among shapes and colors were to animate the work of almost every major artist of the period, especially in Paris. Photographers were no exception.

When László Moholy-Nagy (Hungarian, 1895–1946) made his first visit to Paris, in 1925, he had been a photographer for only a short while. In Berlin, he had made photograms and photomontages, but by the time he visited the French capital, he had a camera in his hands and was seeking pictures framed from a point of view that would allow them to be complete in themselves. It was summer, and he was passing through on vacation with Giedion and the Dutch painter Theo van Doesburg. Looking at Moholy's photographs of the Eiffel Tower and Notre Dame (see figs. 5, 6), it is hard to believe that he climbed the tower or the cathedral without the company and comment of his colleagues. The photographs are strongly abstracted in detail and structured by predominant diagonals. If his view of one tower of the great cathedral seen looking down from the other belies the traditional character of the monument, his view looking up the ironwork maze of the Eiffel Tower is the perfect photographic complement to a structure that rises to a height of three-hundred meters with very few components that are vertically plumb. Gustave Eiffel and his engineers had designed the tower so that almost everything is askew, providing little that lines up with the rest of Paris. After all, its function is unlike any other building in the city. In fact, it is not a building; it is not even a structure, as Eiffel's iron bridges are. It is a machine for viewing Paris, and as such it maintains its own identity.

Giedion did not use Moholy's photographs to illustrate his book; he used his own. Compared to Moholy's, they are less expressionistic and self-referential. Any personal statement that Giedion had to make was contained in his perceptive discussion of the structure as a whole and not in the particular photographic arrangements of its details. Not surprisingly, in his photo-

figured as one of the central symbols of Guillaume Apollinaire's first calligram, "Lettre-Océan," first published in *Les Soirées de Paris* in 1914.[7] In 1923, it was the setting of René Clair's first film, *Paris qui dort* (The Crazy Ray). In the same year, along with other structures by Eiffel, it substantiated Le Corbusier's ideas in the first chaper, "Esthetique de l'ingenier, architecture" (The Engineer's Aesthetics are Architecture), of his first book, *Vers une architecture* (Towards a New Architecture).[8] It was the second illustration in Sigfried Giedion's (German, 1888–1968) pioneering book of 1928, *Bauen in Frankreich, Bauen in Eisen, Bauen in Eisenbeton* (French Structures in Iron and Reinforced Concrete), in which he described its prominent structure through which the rest of nature and civilization is viewed: "In the aerie rise of the Eiffel Tower . . . one runs up against the fundamental aesthetic experience of contemporary structures: through the meager net of iron that stays stretched

8

graphs, even when of details, he was more attentive to the engineering of the tower itself, its elevators, walkways, and stairs. Soon after the Eiffel Tower, Giedion discovered a second structural machine that would inspire avant-garde photographers through the 1930s: the mechanized transporting bridge of Marseilles harbor, the Pont Transbordeur, built in 1905. Giedion's photographs of the bridge accompanied the second article in a three-part series on new French architecture for the fine-arts periodical *Der Cicerone* in 1927.[10] A caption to a view (fig. 7) looking down on the transporting platform and boats on the water reads: "Full of new possibilities of looking: everything is founded on movement."[11] For Giedion, Moholy, and, later, for Krull, the Eiffel Tower and the Marseilles bridge were more than symbols: they were mechanical structures that acquired the dynamic aspect of a new aesthetic if one became a part that moved within.

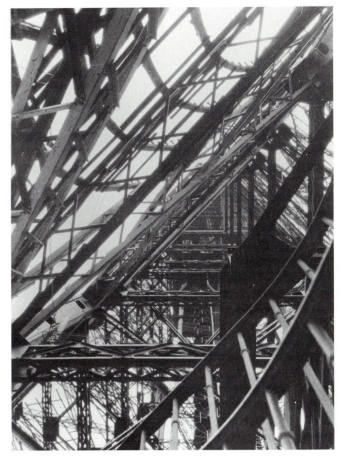

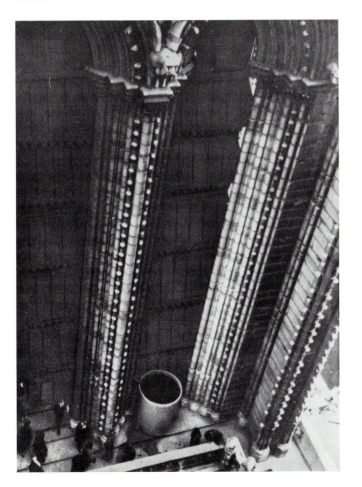

Above
FIGURE 5. László Moholy-Nagy (Hungarian, 1895–1946). *The Eiffel Tower*, 1925. Silver-gelatin print; 22.7 × 16.9 cm. Houston, The Museum of Fine Arts, purchased with funds provided by the Bernstein Development Foundation (84.234).

Left
FIGURE 6. László Moholy-Nagy. *Notre Dame, Paris*, 1925. Halftone reproduction printed in *Der Querschnitt* 12 (1930), inserted between pp. 796 and 797. The Art Institute of Chicago, The Ryerson Library, Mary Reynolds Collection.

9

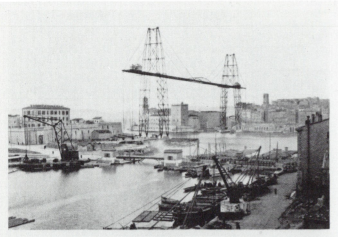

Abb. 5. BEZIEHUNG und DURCHDRINGUNG: Pont Transbordeur im Hafen von Marseille. 1905
Über dem Wasser schwebende Fähre, die an Seilen an dem hochgelegenen Steg gleitend aufgehängt, den Verkehr der beiden Hafenseiten vermittelt. Dieser Bau ist nicht als »Maschine« zu werten. Ebensowenig kann er aus dem Stadtbild fortgeleugnet werden, dessen phantastische Krönung er bedeutet. Aber sein Zusammenwirken mit der Stadt ist weder »räumlich« noch »plastisch« faßbar. Es entstehen s c h w e b e n d e Beziehungen und Durchdringungen. Vorboten neuer Gestaltung

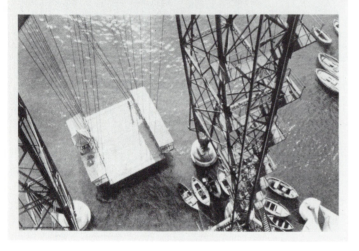

For the literary imagination, the irresistible attraction of being in and of the Eiffel Tower was most recently recaptured in the form of a short essay by Roland Barthes:

But in this movement [getting up inside it] which seems to limit it, the Tower acquires a new power: an object when we look at it, it becomes a lookout in its turn when we visit it, and now constitutes as an object, simultaneously extended and collected beneath it, that Paris which was just now looking at it. The Tower is an object which sees, a glance which is seen. . . .[12]

Photographs taken from inside the tower usually show details of the structure itself or Paris between iron

trusses, but not "a glance which is seen." Nor do photographs of the structure taken from the outside succeed at this. Although old postcard views at night showing the searchlight that once radiated from its pinnacle may symbolize its lookout glance, the tower is usually isolated by the night from what it sees. Barthes further observed:

The Tower (and this is one of its mythic powers) transgresses . . . this habitual divorce of *seeing* and *being seen*; it achieves a sovereign circulation between the two functions; it is a complete object which has, if one may say so, both sexes of sight. This radiant position in the order of perception gives it a prodigious propensity to meaning: the Tower attracts meaning, the way a lightning rod attracts thunderbolts; for all lovers of signification, it plays a glamorous part, that of a pure signifier, i.e. of a form in which men unceasingly put *meaning*. . . .[13]

Only a writer can describe the tower that way, with all of its magical and miscellaneous attributes neatly aligned like an accountant's decimal points and summed. A painter has similar privileges; Delaunay not only compounded the views he found in and around the tower but those he had collected in the form of postcards as well. A photographer knows, more than other artists or writers, that he cannot be sure to reduce even two fractions of any experience to the same denominator in one exposure. Unless he resorts to sequences, superimpositions, or montages, he must deal with what light reveals from a single point of view, at a specific time, with the only certainty being that what he records in that sliver is optically and temporally accurate unto itself. At least that is the abiding myth of the photographer's craft that, like an aphorism, still disturbs our notion of truth.

In considering Krull's photograph of the tower's shadow, apart from its rendering in the *Vu* article, one can say that conceptually it hints at Barthes's two sexes of sight: on the one hand, the tower is seen as part of and by part of Paris, even though it is ephemeral and indirect; on the other, it searches the city, peering into courtyards and upper story windows. But, that interpretation

FIGURE 8. Germaine Krull. *The Eiffel Tower*, 1928/29. Rotogravure reproduction published as plate 100 of *100 X Paris* (Berlin, 1929). The Art Institute of Chicago, The Ryerson Library, Carrie Lake Morton Fund.

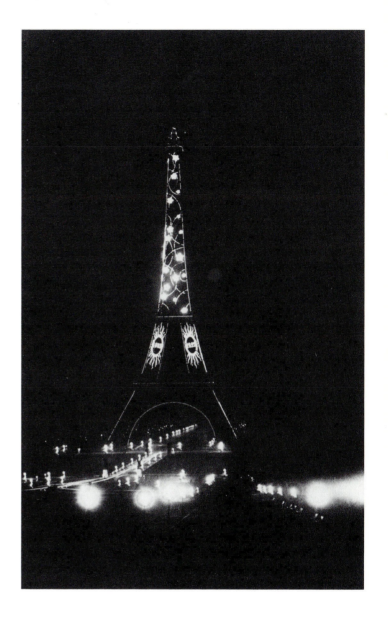

is easier to make *after* reading Barthes. Krull's own intentions in this regard are ambiguous, and the photograph silent. Krull made no published statement of her own until 1930, and then she dealt with photography in general: "The first skill of a photographer is to know how to look In one click of the shutter, the lens records the world externally, and the photographer internally The camera doesn't have to invent, contrive, or fake. It is not painting or imagination. The photographer is a witness, a witness to his own time."[14] By the time this statement was published, Krull had already issued *Métal* and had abandoned making abstractions of iron structures. She had begun to realize that the contingencies of street photography and photojournalism often force the photographer to work intuitively from a momentary reflex on the spot rather than through long, critical introspection. In that regard, photographs are hard to credit as being so purposefully intricate as works by painters or writers. To make up for such a loss, photographs, because of the inadvertence of their detailed record of reality, provide a larger jungle in which the viewer's interpretations may prowl. But, in searching for verification of *our* way of seeing Krull's photograph of the shadow, one finds, unfortunately, no other photograph of hers of the Eiffel Tower or the Marseilles bridge that points a vector in Barthes's direction. A photograph of the tower at night (fig. 8) that served as the last plate in Krull's book *100 X Paris* (1929) is, like the majority of the other plates, an updated but standard view of a famous site.[15] It is more memorable for the Fernand Jacopozzi lighting design that animated the tower than for any special photographic virtue.[16] Another plate from the same book reproduces a view through the pylons of the base that frame the Trocadéro Palace in the distance; the composition is scarcely different from those taken for postcards and souvenirs of the 1900 Exposition held in Paris on the Champ de Mars. But, like postcards, these scenic photographs of Krull's were commercial in nature, made to be consumed by a public concerned not with personalities and ideas, but with places. In her defense, there are perhaps no photo-

graphs of the structure by anyone else that better anticipate Barthes's conception of the tower than the one she took of its shadow, even if her intentions might have been otherwise.

Although Krull shot assignments for *Vu*, made scenic photographs of Paris for a living, and published a portfolio of nudes, her first and lingering identity in Paris derives from the photographs in *Métal*. Taut, abstract, and bluntly matter-of-fact, the unrelenting welter of straightedged forms that cage the eye was an obsession of hers that Fels termed a "new romanticism."[17] The "Valkyrie of Iron," as the publisher Eugène Merle dubbed her at one of his soirées, was celebrated by sev-

11

eral writers in 1929 through enthusiastic reviews of *Métal*.[18] In addition, the May issue of *L'Art vivant* printed an article inspired by her work, "Le Métal, inspirateur d'art."[19] Two months later, Jean Galotti devoted to Krull one of his series of articles entitled "La Photographie est-elle un art?" (Is photography an art?).[20] These notices, Krull's highly visible photo-essays that had begun the year before in *Vu*, her inclusion in several of the most important avant-garde photography exhibitions of the period, her publications, and a small monograph by Pierre Mac Orlan in 1931 constitute a reception and recognition experienced by few photographers at the beginning of their careers in Paris.[21] Yet, in a little more than a decade after her arrival in Paris, Krull disappeared from France altogether—traveling first to South America, then to Africa, and finally to the Himalayas—and was forgotten.[22]

According to Krull's memoirs, Robert and Sonia Delaunay were her first acquaintances after she arrived in Paris in 1924.[23] The work she showed to them was of iron structures. Robert Delaunay's interest must have been keen, for he often used photographic images as a point of departure for his paintings.[24] In addition, Krull recounted in her memoirs that Delaunay offered to have Krull's photographs, which had been rejected by the annual photographic salon, hung next to his paintings in the 1926 Salon d'Automne. This gesture of support was not realized, for records show that Delaunay did not participate in any salon that year and had not, for that matter, exhibited in that particular salon since 1906.[25]

Krull's arrival in Paris coincided exactly with the beginning of Delaunay's second series of paintings of the Eiffel Tower. It is possible that Krull may have sparked his renewed interest in the most famous iron structure in Paris, but it is not probable. Delaunay would have had his own reasons for returning to the Eiffel Tower as a subject, for its motifs are to be found in many of his important paintings. Furthermore, Delaunay, as well as several other artists at the time, seems to have been infatuated with a *specific* aerial photograph of the tower (fig. 9). The photograph, taken almost directly above the tower, shows it curiously reduced to a well-contained geometric shape within the curving walkways of the Champ de Mars. Equally fascinating is its sister shadow latticed northward across the park. It seems infinitely more likely that Delaunay and his work influenced, or at least encouraged, Krull. It may be that she even saw this aerial photograph before she made her photograph of the

shadow, either through Delaunay and the painting, drawings, or lithograph (fig. 10) he made from it,[26] or when it was published by Le Corbusier and Amédée Ozenfant in an issue of *L'Esprit nouveau* late in 1925.[27]

Moving in and around the Eiffel Tower, trying to accumulate and depict the numerous aspects of its character in a single picture, had been an early theme of Robert Delaunay's. He began his first paintings of the tower as a solitary and dominating icon seen from a distance in 1909. In the next two years, the tower, or some form of its skeletal iron structure, was the inescapable subject of nearly all of his work, culminating in the fall of 1911 in several paintings, one of which (fig. 11) is owned by The Art Institute of Chicago. The tower in these paintings is seen simultaneously from several points of view which, together, give it the appearance of falling to pieces as if being destroyed by an earthquake. In Delaunay's brand of Cubism (the painter called it his "destructive period"), the tower seems to be part of a particular instant, like a stop-action photograph typical, although not at all naive and unassuming, of the thousands of awkward gestures found in the amateur snapshots of his day.

Simultaneity, however, was a term Delaunay had borrowed (starting in 1912) not from photography but from the work of Michel Eugène Chevreul, whose color theories had influenced Georges Seurat and the Neo-Impressionists whom Delaunay considered his antecedents.[28] Through the work of both scientist and the painters, simultaneity inevitably became a concern of color for Delaunay. But, before he applied the term to color, it was temporarily ocular, even bordering on the illusionary, if we exercise our imagination and eyes. For example, in the case of a painting the size of Chicago's *The Red Tower (Champ de Mars)*, which is 160 centimeters (64 inches) in height by 128 centimeters (51½ inches) in width, if we stare for a long time at the white apartment buildings near the base of the tower and then suddenly shift our gaze to the blank white area inside the decorative arch, the eidetic image of the pattern of dark windows flickers almost long enough to create a double image similar to the juxtaposition of the same two motifs painted palely, and in a slightly smaller scale, to the immediate right. Although illusions as fugitive as this are not intended to carry much meaning, it should be noted that at this time in the development of Cubism they are unique to Delaunay; the technique of optically juxtaposing images by eye movement does not work with the

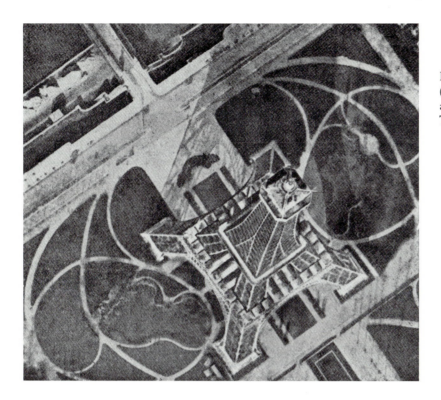

FIGURE 9. Page from *L'Esprit nouveau* 24 (1925), with halftone reproduction of an aerial photograph by Stavba of the Eiffel Tower and the Champ de Mars.

FIGURE 10. Robert Delaunay (French, 1885–1941) *The Eiffel Tower*, 1926. Lithograph published as plate 3 of Joseph Delteil, *Allo! Paris!* (Paris, 1926). The Art Institute of Chicago, The Ryerson Library, Mary Reynolds Collection.

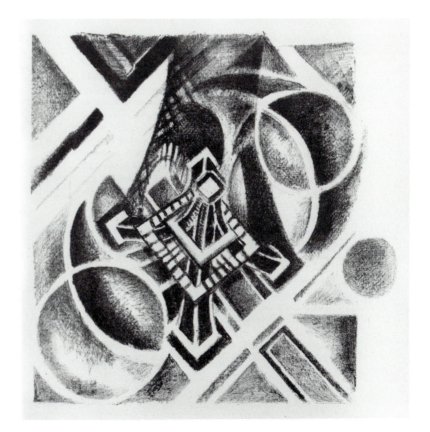

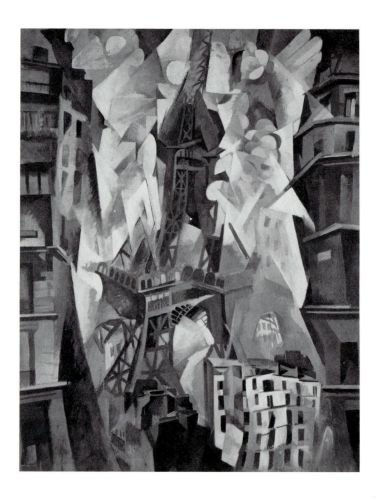

Left
FIGURE 11. Robert Delaunay. *The Red Tower (Champ de Mars)*, dated 1911. Oil on canvas; 160 × 128 cm. The Art Institute of Chicago, Joseph Winterbotham Collection (1959.1).

Below
FIGURE 12. Robert Delaunay. Halftone reproduction showing unfinished state of *The Red Tower (Champ de Mars)*, (fig. 10) in Carl Eisenstein, *Die Kunst des 20. Jahrhunderts* (Berlin, 1926), p. 342. The Art Institute of Chicago, The Ryerson Library, gift of Carter H. Harrison.

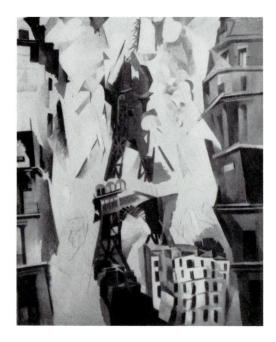

drab palette and dense compositions of Picasso or Braque.[29] With Delaunay, the active component of simultaneity is, at least partially, retinal.

If Delaunay unintentionally achieved an illusion formed from the simultaneous perception of the afterimage of one part of the canvas on another, it at least occurred at the appropriate time. *The Red Tower (Champ de Mars)* was not finished by the end of 1911. In fact, it was exhibited unfinished in 1912 and 1913.[30] Delaunay's early habit of exhibiting unfinished canvases was even remarked upon by Apollinaire in his review of the painter's first exhibition (March 1912).[31] Plate three of a limited-edition publication accompanying that exhibition documents the unfinished state. This catalogue was headed by Apollinaire's poem "Les Fenêtres" (Windows), which Delaunay's technique of seeing things simultaneously had inspired.[32] Later, in 1926, the same reproduction appeared in Carl Eisenstein's *Die Kunst des 20. Jahrhunderts* (Art of the Twentieth Century) (fig. 12).[33] From these first reproductions, it is clear that the area of "illusionistic" reference in the painting was added after 1911, which would have been during, or just after, Delaunay's first successes in extending the notion of simultaneity from the primacy of objects and the realm of the ocular to color. Delaunay's first statement about his own work, a poem entitled "La Lumière" (Light) written in the summer and fall of 1912, reveals the importance of the eye in one of his several definitions of simultaneity:

The Eye is our highest sense, the one which communicates
 most closely

with our *brain and consciousness*, the idea of the living movement of
the world, and its movement is *simultaneity*.[34]

Through the year, he kept developing the idea of simultaneity and of ocular perception.[35] His last variant of the text/poem ended with the painter realizing light as color: ". . . And when light expresses itself completely, all is color. Painting is in fact a luminous language."[36]

The newly painted areas of *The Red Tower* do not at all suggest Delaunay's theories of the simultaneity of colors; the additions are mostly shards of light. Perhaps, Delaunay simply added them and the "building/arch" motif from a previous tower painting, wanting to leave intact what was already a hard-won success. Since *The Red Tower* seems to be the only painting of the series that has this illusionary potential (a blank space between the arch and adjacent apartment buildings), it is hard to make much of it, especially knowing that Delaunay painted his most important motifs over and over again. On the other hand, one might imagine that what was so lightly added needed to be as tentative as the illusion itself. But, no matter what Delaunay's intentions were, or how one interprets this painting, his work in this period and this curious addition are, at least, proleptic examples of Giedion's observation of the fundamental aesthetic experience of contemporary structures: "They lose their delineated forms orbiting below, mixing one with another."

In 1923, the Brazilian painter Tarsila do Amaral purchased *The Red Tower* (one assumes that it was then complete) and took it to São Paulo where it was shown in June 1924 in conjunction with a conference on contemporary French painting.[38] The conference was conducted by Blaise Cendrars, whose poetry, like Apollinaire's, had been inspired by Delaunay's ideas of simultaneity.[39] In his remarks, Cendrars described the sensation of being in and around the tower with Delaunay:

None of the artistic formularies known up to our time can claim to have plastically resolved the problem of the Eiffel Tower. Realism diminishes it; the old laws of Italian perspective make it slight. The Tower rises above Paris as slender as a hat pin. When we moved away from it, it dominated Paris, stiff and perpendicular; when we approached it, it tilted and leaned over us. Seen from the first platform, it spiraled upward, and seen from the top, it sagged in on itself with spread legs and indrawn neck. Delaunay wanted equally to show Paris all around it and to situate it in her midst. We tried every point of view, we looked at each of its angles, each of its sides and . . . those thousands of tons of iron, those thirty-five million bolts, those three-hundred meters of girders and beams, those four arches spanning one-hundred meters, that whole dizzying mass flirted with us. . . . So many viewpoints in coming to terms with the Eiffel Tower.[40]

The tower could be seen everywhere in Paris. It could not be ignored and, because it had become so popular and profitable, it could not be gotten rid of. That is why its detractors hated it so much. Guy de Maupassant, the most stubborn of the original detractors of 1887, even said he used to lunch in the tower's restaurants because it was the only place in Paris from which it could not be seen. On the other hand, at least he could see all of his beloved Paris, which is why it attracted those making visits to the city. Consequently, many of the best photographs in or of the tower were made by visitors to the city. In addition to Giedion (from Germany), Moholy (from Hungary, via Berlin), and Krull, there were two other photographers from Germany: Else Thalemann (German, 1901–1985), an assistant to Ernst Fuhrmann at the Folkwang Auriga-Archiv in Essen, who came as a visitor in the late 1920s; and Ilse Bing (German/American, born 1899), a scholar-turned-photojournalist who came to reside in Paris in 1930.[41]

Like Moholy and Krull, Thalemann and Bing did not consider the tower to be a shrine, a memorial, or even a monument. It was an amusement not unlike the Ferris wheel, the first example of which appeared in Chicago just a few years after the tower was opened. By the turn of the century, a Ferris wheel was installed near the Champ de Mars and visitors had their choice of the tower or the wheel, or both. The forty or so gondolas of the Ferris wheel were much the same as the elevator cars that took visitors from the ground to the first platform of the tower. No photograph, even those that mimic the vertiginous view looking down on the rapidly diminishing perspective, could approximate the acrodynamic exhilaration of the ride up; so Thalemann and Bing, like Krull, opted for the stairs. There, they were exposed to the weather, as well as to the ordered clutter of the infrastructure, which is all the tower is until one reaches the restaurants on the first platform. For Thalemann, the tower was a source of abstract forms (see fig. 13), as it had been for Krull, but Thalemann had a greater sense of the exquisite and was less concerned with exaggerating the immensity and power of the structure as if she were a

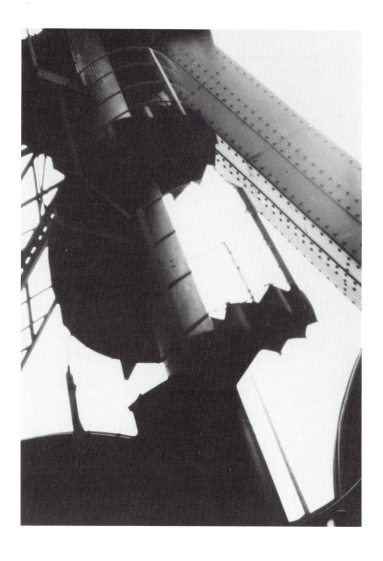

worker scurrying through part of Fritz Lang's film *Metropolis*. Bing also found the tower accessible in every way. Still outscaled but benignly passive, her network of iron and air entertains rather than oppresses those inside (fig. 14). That delightful quality of the tower's open seductiveness was captured outside on the ground as well by Thalemann in an intriguing view (fig. 15): Four men in long, dark coats and derby hats approach the tower on foot. It is probably chilly or a little windy, for their hands are in their pockets. They seem to know exactly what they want. Their manner is firm and direct as they stride purposefully toward their target pleasure. The distant tower, vincible and erect, watches and waits, a siren of either sex. It is a photograph that Barthes would have loved.

When André Kertész (Hungarian/American, 1894–1985) arrived in Paris from his native Budapest in the fall

of 1925, he was an amateur photographer. His first photograph of the Eiffel Tower that year is one of the quintessential vignettes of Paris—a view across the rooftops toward the tower, which rises out of an atmospheric mist (fig. 16).[42] It was a beginning, a first step, and the best way for him to say, "I am in Paris," which is what he did in sending the photograph to his sweetheart back in Budapest. Although such views by amateurs taken of the Parisian rooftops were almost always sentimental, Kertész's view was stylishly modern as well. From his first days in Montparnasse, he had been surrounded by immigrant painters, sculptors, designers, dancers, architects, and writers who had come to Paris, as he had, to find their fortune and to be nurtured by and work within the Modernist idiom. In fact, the window from which his first view of the tower was made was not of a bohemian garret studio, but of a modern building designed by the Hungarian architect André Sive, a partner of Erno Goldfinger, whom Kertész was visiting there. If the mist insinuated an alluring romantic atmosphere, it also clarified the geometry of the composition. In his view, Paris is simple, sweet, and spare. If Kertész was an amateur, he was a beguiling one.

By 1929, Kertész had become one of the leading photojournalists of Europe. A sophistication gained without abandoning the virtues of naiveté was what differentiated him from the others. Few of his contemporaries could be as charming without being cloying. His vision of Paris was in demand in France, Germany, and, occasionally, even in Budapest. In addition to the illustrated weeklies, his photographs, through exhibitions and critical praise, appeared in the company of ones by Man Ray, Eugène Atget, Moholy, and Krull.[43] The little magazines of the literary avant-garde gave Kertész's photographs currency, as did the sumptuous publication *Art et médicine*, which was distributed to physicians' waiting rooms and offices.

For the fortieth anniversary of the Eiffel Tower, Kertész received an assignment from *Vu* to visit the tower and bring the older illustrations of its construction and

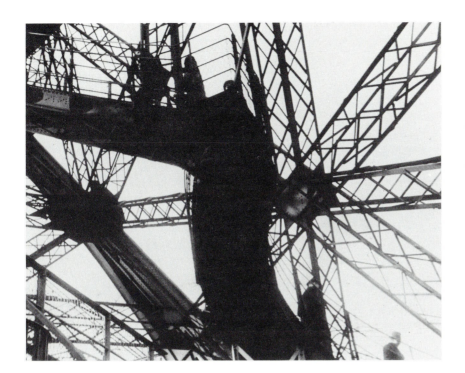

FIGURE 14. Ilse Bing (German/
American, born 1899) *Untitled (The
Eiffel Tower)*, 1931. Silver-gelatin
print; 22.3 × 28.2 cm. The Art In-
stitute of Chicago, Julien Levy Col-
lection, gift of Jean and Julien Levy
(1975.1131).

Below
FIGURE 15. Else Thalemann. *The
Eiffel Tower, Paris* (no. 30893), c.1929.
Silver-gelatin print; 12.5 × 17.5 cm.
The Art Institute of Chicago, restricted
gift of Helen Harvey Mills in memory
of Kathleen W. Harvey (1986.153).

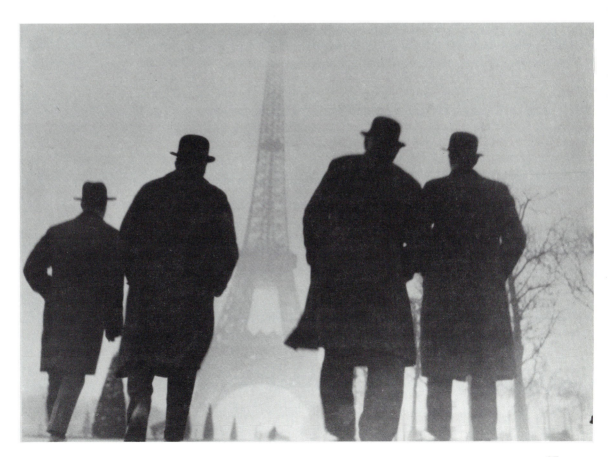

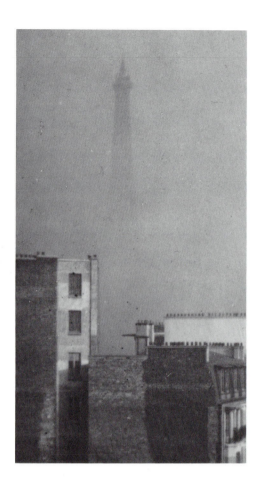

history up to date.[44] Kertész was a better choice for an anniversary article than Krull, because his photographs would deal with the tower for what it was, the major tourist attraction of Paris. He went in the company of his compatriot Brassaï, who was then earning his living as a journalist and had not yet devoted himself to photography. One of the photographs chosen for the article shows Brassaï having a souvenir portrait made with his face peering through a photographer's placard. Two others show the interior of Eiffel's apartment at the top and a postcardlike view of the tower through the branches of a tree. The largest reproduction in the layout, however, was destined to become one of Kertész's best-known photographs (fig. 17).[45] Its angled view looking down on the square directly beneath the tower was not so artificial and contrived as Moholy's or Krull's views looking up, nor was the scene rigidly depopulated. His vantage point did not even have to be earned by athletic exertion— Kertész could have taken the elevator. Millions of tourists during the past four decades had seen the same view from the inside rail of the first platform, but no professional photographer had captured it quite this way and put it into print.[46] For Kertész, it was not so much a question of aesthetic doctrine that tilted his camera

FIGURE 16. André Kertész (Hungarian, 1894–1985) *The Eiffel Tower*, 1925. Silver-gelatin contact photograph printed on postcard stock; 7.2 × 4 cm. Chicago, collection of Nicholas Pritzker.

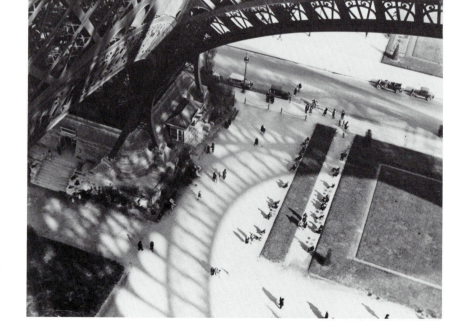

FIGURE 17. André Kertész. *Shadows of the Eiffel Tower*, 1929. Semi-glossy, single-weight silver-gelatin print mounted on vellum paper; 16.5 × 21.9 cm. The Art Institute of Chicago, Julien Levy Collection (1979.77).

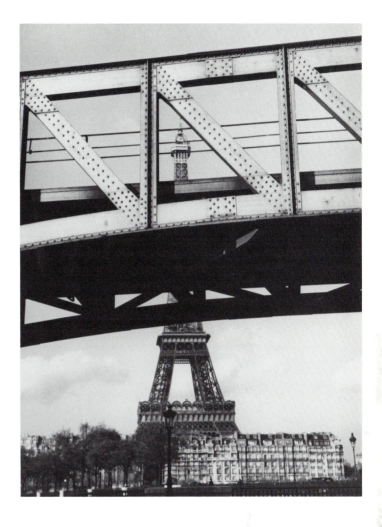

FIGURE 18. André Kertész. *The Eiffel Tower and the Debilly Footbridge*, 1933. Semi-glossy, single-weight silver-gelatin print; 24.4 × 18.3 cm. The Art Institute of Chicago, Ada Turnbull Hertle Fund (1984.541).

down, but rather, as with most of his work, doing what came naturally.

Curiously, the *structural* essence of the tower that had attracted the photographers and architects of the avant-garde is almost completely absent in this view, although it appears otherwise. In Eiffel's design, the arches between the splayed foundation pylons are the most feminine feature of the tower's personality, as well as its most decorative accessory. Like a petticoat, they support nothing but an outer dress. Any photograph featuring them would have been strictly out of character for Giedion, Moholy, or Krull, but for Kertész, whose photographs favor persuasiveness above insistence, the seductive tracery of light rather than the domineering network of iron was more expressly Paris. One might argue that the arches were merely a concession that Eiffel was forced to make to architectural taste, but if one studies the tower at length, it is this decorative touch and the visual weight of the architecture of the platforms that give grace and the illusion of a curving sweep to the pylons, which are in fact straight.

An engineer's sleight of hand must be calculated, budgeted, and blueprinted in advance; a photographer's is chanced upon and held in the suspension of time. Since the artists of Kertész's era sought ephemeral truths more than they respected conventional wisdom, it is no wonder that Giedion felt, at least for a moment on the Marseilles bridge, that everything was founded on movement. A photographer can destabilize the most solidly constructed work of engineering with the slightest tip of the camera and still be optically correct. Playing with and seeking the truths of illusion constitute most of his art.

One of the last photographs Kertész made of the Eiffel Tower several years before leaving for New York is a view taken from the northwest across the Seine toward the tower (fig. 18).[47] A row of apartment buildings on the avenue de la Bourdonnais masks the tower from the top of its decorative arch down. Because a geometry of ironwork occupies the upper two-thirds of the composi-

tion, the lower parts of the tower and the buildings around it achieve a harmony that none of the original detractors of the tower would have dreamed possible. Something else about this photograph, however, is different from all of Kertész's previous views of Paris. The tower rises, but before it can soar, it is cut off by the square and triangular patterns of the iron beams of the Debilly footbridge. The top of the tower emerges between one of its triangular openings. As our eyes wander about the lower third of the photograph, peripherally the pinnacle does not seem to align with its base, but as soon as we move our eyes up, it does. Formally, it is clever and playful; psychologically, it is unsettling.

In 1933, the year that this puzzle was made, Kertész had completed a set of optically distorted female nudes for publication in the February issue of the humor magazine *Le Sourire*. They, too, are clever, playful, and unsettling. Later in the same year, Kertész's mother died, and he remarried. New themes began to appear in his

work. Even death and despair emerged tenderly through his lyrical temperament (see figs. 19–20). We know enough about Kertész's biography to doubt that the unsettling elements in the photographs made around 1933 and the year following were totally inadvertent. But, as he always tried to keep the emotions of his private sorrows, as well as his disastrous first marriage, hidden, it is not surprising in his photographs at this time to find his grief so deliberately subsumed by playful conceits; one wonders if Kertész ever suggested lamentation without first providing for its alleviation. One can always argue that the conceits were no more than gratuitious juxtapositions that caught his eye, but that is a common photographic ruse with which Kertész so easily disguises his secret self from the viewer who consumes the work for his own amusement. Because Kertész was even more beguiling as a master than he was as an amateur, one must be careful not to confuse the illusion of darker moods for their delitescence while searching for the photographer's personality in his work. One senses them best when his lyrical charm turns to wit, and his wit ever so slightly to a provocation that touches on our sense of loss and denial.

We now return to the last photograph of the tower. As we glimpse it, the venerable structure is suddenly and forcefully canceled over by a pedestrian bridge which, although it was never celebrated by a famous painter or a poet, at least has the distinctive honor of having been designed for an ancient utilitarian function. The tower's detractors may think it a fitting end to the monstrosity that had ruined Paris by being visible everywhere. But, even as it once appeared in Delaunay's paintings of 1910 and 1911 to be tumbling down along with the old laws of perspective representation, it survives the experiment. Our eyes stare and then wander, the rigid pinnacle moves, and the photograph does not fix the world before us. Just as the photographer can remake the world in a few seconds, we look again—this time trying to forget about Kertész, Delaunay, Krull, psychology, simultaneity, and symbolism, trying to regain the innocent experience of snapshots and *not* think about our perceptions. The tower keeps drifting out of line. We stare harder, reminding ourselves that it is just a simple photograph, an amusing coincidence of forms. Yet, as we are lost again in thought, it becomes a form in which to put meaning. We picture to ourselves what Giedion said: we see another structure through which other things flow.

Left
FIGURE 19. André Kertész. *Chez Kisling*, 1933. Semi-glossy single-weight silver-gelatin print; 17.8 × 24.9 cm. The Art Institute of Chicago, Ada Turnbull Hertle and Wirt D. Walker Funds (1984.549).

Facing page
FIGURE 20. André Kertész. *On the Boulevards*, 1934. Semi-glossy single-weight silver-gelatin print; 23.8 × 18.1 cm. New York, John C. Waddell Collection.

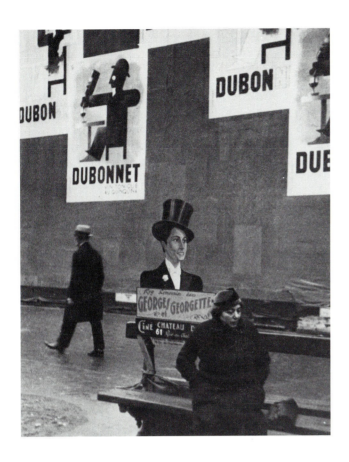

specifically on the back—most dates appeared on the front with a signature. If the 1925 date is correct, then the photographs of the Eiffel Tower included in *Métal* would have been the ones taken on the *Vu* assignment. It is possible that all of the *Métal* plates were printed in 1927 and that the Fels text was completed in December 1927, as the monograph states, but that the publication either was not distributed or went unnoticed. In her memoirs (see note 3), Krull recounted meeting Vogel and receiving the Eiffel Tower assignment for the first issue of *Vu*. Her photographs, however, did not appear in the first issue (March 1928), but in the eleventh (May 1928—May was the month in which the tower opened in 1889). The full foliage of the trees indicates that the photograph was taken later in the year than May: therefore summer/fall 1925, 1926, or 1927 are all possible dates. It is not unreasonable to assume that Vogel commissioned Krull to take photographs for his as-yet-unpublished magazine as early as the spring of 1927 (the *Métal* photographs reveal no season), since Vogel had first met André Kertész at the photographer's debut exhibition at the Galerie Au Sacre du Printemps in March 1927 and at that time enlisted his participation in the new venture.

2. Germaine Krull and Florent Fels, "Dans toute sa force," *Vu* 11 (May 30, 1928), p. 284. The text of the *Vu* article is nearly identical to the last paragraphs Fels wrote for the introduction to *Métal*.

3. Germaine Krull, *Germaine Krull, Fotografien, 1922–1966*, (Cologne, 1977), p. 123.

4. Ibid.

5. An open letter of protest, published on February 14, 1887, in the newspaper *Le Temps* and addressed to Charles Adolphe Alphand, the minister of public works, stated that the proposed tower was "useless and monstrous" and that it would profane the city of Paris and "the most noble monuments to which human genius has ever given birth." Among the signatories were the painters Ernest Meissonier, Jean Léon Gérôme, and Adolphe William Bouguereau; the composer Charles Gounod; the architect Charles Garnier; the dramatist Victorien Sardou; and the writers Alexander Dumas the younger, Joris Karl Huysmans, François Coppée, Sully Prudhomme, and Guy de Maupassant. Most of the signatories made up with Eiffel after the success of the tower was assured. The full text of the letter appears in English in Joseph Harriss, *The Tallest Tower, Eiffel and the Belle Epoque* (Boston, 1975), pp. 20–22.

6. Delaunay actively returned to the subject of the Eiffel Tower in 1924, unless the 1922 dating in Guy Habasque's catalogue raisonné for no. 197 is correct. See Guy Habasque, "Liste des expositions des oeuvres de Robert Delaunay," in Pierre Francastel, *Du Cubisme à l'art abstrait* (Paris, 1957). (Habasque numbers refer to this list.) See also note 26.

7. *Les Soirées de Paris* was a private publication begun in 1912 and financed by its contributors: Guillaume Apollinaire, André Billy, André Salmon, André Tudesq, and René Dalize (René Dupuy). For further information about this publication, see Marcel Adema, *Apollinaire*, trans. Denise Folliot (London,

NOTES

The author is especially grateful to Helen Harvey Mills for her years of support for the Department of Photography.

1. Germaine Krull, *Métal* (Paris, n.d.), portfolio of sixty-four loose plates printed in collotype, preface by Florent Fels, cover design by Tchinowkou. The copy in the Art Institute's Ryerson Library was acquired through the Mary Reynolds Fund, and a gift of the Photographic Society, Arthur D. Myhrum, and William McKittrick.

Métal is dated 1927 in Krull's 1977 memoirs (see note 3) and in Pierre Mac Orlan's 1931 monograph (see note 21). It is possible, however, that the portfolio actually appeared in late 1928, since a review in the January 15, 1929, issue of the Belgian publication *Variétés* (pp. 509–10) notes its publication, and reviews in *L'Art vivant* in 1929 state that it was "just published" (note 19) or "recently published" (note 20). Since Florent Fels was the publisher of *L'Art vivant* (which began publication in 1925), it seems odd that he would wait until 1929 to have *Métal* reviewed, especially considering he was the author of its introduction. It is also possible, however, that the inscription on the back of the photograph, "*Champ de Mars, 1925*," is accurate, even though it is not thought to be in Krull's hand; photographers were not then in the habit of dating their photographs so

1954), pp. 152–54. An excellent discussion of the importance of "Lettre-Océan" can be found in Roger Shattuck, "Apollinaire's Great Wheel," in *The Invented Eye: On Modern Literature and the Arts* (New York, 1984), pp. 240–62.

8. Charles Edouard Jenneret (Le Corbusier), *Vers une architecture* (Paris, 1923), pp. 1–10. This chapter was published earlier under the same heading in *L'Esprit nouveau* 11-12 (1921), ed. Le Corbusier and Amédée Ozenfant, pp. 1328–35.

9. Sigfried Giedion, *Bauen in Frankreich, Bauen in Eisen, Bauen in Eisenbeton* (Leipzig/Berlin, 1928), p. 7.

10. Sigfried Giedion, "Zur Situation der Französischen Architektur II," *Der Cicerone* 19, 6 (June 1927), pp. 174–89. The first part of the article appeared in 19, 1 (Jan. 1927), pp. 15–23; and the third and final part in 19, 10 (Oct. 1927), pp. 310–17.

11. Ibid., p. 177.

12. Roland Barthes, "The Eiffel Tower," in *The Eiffel Tower and Other Mythologies*, trans. Richard Howard (New York, 1979), p. 4.

13. Ibid., p. 5.

14. Germaine Krull, *Etudes de nu* (Paris, n.d.), portfolio of twenty-four plates printed in collotype with an introduction by the photographer, unpag. The portfolio is dated 1930 in Krull's memoirs (note 3). A copy of the portfolio is in the Art Institute's Ryerson Library.

15. Germaine Krull, *100 X Paris* (Berlin, 1929), one hundred plates printed in rotogravure, introduction by Florent Fels. The Eiffel Tower is seen in pls. 41–42 and 100. A copy of the book, purchased through the Carrie Lake Morton Book Fund, is in the Art Institute's Ryerson Library.

16. For an article on lighting designs for publicity that touches on the various Citroën decorations of the Eiffel Tower by Jacopozzi and other commissions, see P.P., "Publicité lumineuse," *Arts et métiers graphiques* 4 (Apr. 1928), pp. 250–52, and the following color plate of two 1927 designs for the Grands Magasins du Louvre. The first Jacopozzi designs for the Eiffel Tower were illuminated on July 4, 1925. Subsequent design additions and modifications occurred in 1926, 1927, 1933, 1934, and finally in 1936, after which the designs were removed.

17. Fels, in Krull and Fels (note 2).

18. Krull (note 3), p. 144.

19. Charles Saunier, "Le Métal, inspirateur d'art," *L'Art vivant* (May 1929), p. 361; accompanied by six photographs by Krull on pp. 368–69.

20. Jean Galotti, "La Photographie est-elle un art? Germaine Krull," *L'Art vivant* (July 1929), p. 526; accompanied by three photographs by Krull on the subject of flowers on p. 527 and two photographs from *Métal* on p. 530.

21. Krull exhibited in the "Premier Salon Indépendant de la Photographie," called the "Salon d'Escalier," held in Paris in 1928; an exhibition held in November 1928 at the gallery "L'Epoque" in Brussels; "Der International Ausstellung von Film und Foto," called "Film und Foto," held in Stuttgart in 1929; as well as in annual exhibitions held at the Galerie de la Pléiade in Paris in the early 1930s. In addition to Krull's publications described in notes 1 (*Métal*), 14 (*Etudes de nu*), and 15 (*100 X Paris*), her photographs exclusively illustrated Gerard de Nerval, *Le Valois* (Paris, 1930), with forty-eight rotogravure reproductions; and Germaine Krull and André Suares, *Marseilles* (Paris, 1935). Both are in the Art Institute's Ryerson Library. Pierre Mac Orlan's monograph is *Germaine Krull* (Paris, 1931).

22. Krull was born in 1897 in Wildna, Poland, while her parents were traveling, and died in 1985. Her biography is best given in her memoirs (note 3), although there are omissions and a few mistakes in dating, such as the year of her first exhibition with Kertész, et al., which did not occur in 1925 but in 1928 in the "Salon d'Escalier" (see note 21), and omissions such as the fact that she was married to the cinematographer Joris Ivens between 1927 and 1943.

23. Krull (note 3), p. 117.

24. See the inserted reproductions (*Le Baiser*, 1920; *La Tour Eiffel*, 1910; *La Grand-Roue . . .*; *Les tois Graces fresque de Pompei*; etc.) in Cologne, Galerie Gmurzynska, *Robert Delaunay*, exh. cat. (1983); and Michel Hoog, *Robert Delaunay* (Paris, 1976), cat. nos. 18–19, 51, and p. 56. Other postcard views and photographs owned and used by Delaunay are reproduced in Gustave Vreisen and Max Imdahl, *Robert Delaunay: Light and Color* (New York, 1967), p. 108.

25. Delaunay did not exhibit in the Société des Artistes Indépendants that year either, and had not since 1914. For a listing of Delaunay's exhibitions, see Habasque (note 6), pp. 361ff.

26. The painting, *The Eiffel Tower*, is no. 197 in the catalogue raisonné by Habasque published in Francastel (note 6). *The Eiffel Tower* is dated 1922 in the catalogue raisonné, but 1925 in Amédée Ozenfant, *Art* (Paris, 1928), p. 114. It seems to relate stylistically to those paintings by Delaunay dating from 1925 and 1926. It is nearly the same composition as a drawing dated 1924 in the collection of the Musée National d'Art Moderne, Centre Georges Pompidou, Paris, and reproduced in Michel Hoog, *Robert and Sonia Delaunay* (Paris, 1967), cat. no. 31, p. 71. (Habasque listed no drawings of the tower for 1922 or 1924.) The painting seems to be a refinement of the drawing, which is closer to the photograph. It is, therefore, not unreasonable to consider a later date for the painting. When this adjustment is made, it becomes clear that Krull's friendship with Delaunay began in the same year as his renewed interest in the tower. (See note 1 for a discussion of the problems of dating the Krull photographs of the tower.) Delaunay's lithograph based on this painting was for plate 3 of Joseph Delteil, *Allo! Paris!* (Paris, 1926), which contains twenty lithographs by the artist. The Delteil book includes many views of the city that must have been drawn from aerial photographs.

27. Charles Edouard Jenneret (Le Corbusier) and Amédée Ozenfant, eds., *L'Esprit nouveau* 24 (1925), unpag. The photograph is credited to Stavba and decorates a page heading the section "Expo./Arts./Deco." just above the article "L'Art decorative d'aujourd'hui." The Stavba photograph was also reproduced in the first edition of László Moholy-Nagy, *Von Material zu Archiktur* (Berlin, 1929). For the publication history of this photograph, see Annegret Hoberg, "Série: Eiffeltürme 1922–1930," in Munich, Bayer Staatsgemälde-sammlungen, *Delaunay und Deutschland* (Cologne, 1985), pp. 378–79.

28. See Michel Eugène Chevreul, *The Principles of Harmony and Contrast of Colours and their Application to the Arts*, trans. Charles Martel (London, 1883), 3d ed.

29. It was at this time that Delaunay began to eliminate other densities from his painting, like the buildings between the arches. The buildings may have originally been placed there based on a postcard Delaunay owned showing the tower from such a distance that one can see the buildings on the opposite side through the arches. See note 24 for further references to Delaunay's use of photographs and postcards.

30. For a discussion of the painting, see Angelica Zander Rudenstine, *The Guggenheim Museum Collections, Paintings 1880–1945* (New York, 1976), vol. 1, pp. 102–08.

31. "Robert Delaunay's art is full of movement and does not lack power. Rows of houses, architectural views of cities, especially the Eiffel Tower—these are the characteristic themes of an artist who has a monumental vision of the world, which he fragments into powerful light. It is a pity that most of Robert Delaunay's large canvases are unfinished, whether by design or by accident. One would like to see the effect produced by his intense colors in a carefully finished work." Guillaume Apollinaire in *L'Intransigéant* (Mar. 5, 1912), reprinted in Leroy C. Breunig, ed., *Apollinaire on Art: Essays and Reviews, 1902–1918*, trans. Susan Suleiman (New York, 1972), pp. 206–07. It is interesting to note that Delaunay gave Apollinaire a gift of one of his large unfinished canvases (Habasque [note 6] no. 85), now in the collection of the Folkwang Museum, Essen (see Rudenstine [note 30], pp. 102–08).

32. For a discussion of the conversational poem "Les Fenêtres," see Adema (note 7), pp. 159–60. A translation of the poem can be found in Robert Delaunay, *The New Art of Color: The Writings of Robert and Sonia Delaunay*, (New York, 1978), trans. David Shapiro and Arthur A. Cohen, pp. 169–70.

33. Carl Eisenstein, *Die Kunst des 20. Jahrhunderts* (Berlin, 1926), p. 342.

34. Delaunay (note 32), p. 82.

35. Ibid., pp. 81–86.

36. Ibid., p. 86.

37. Giedion (note 9).

38. For further information on the São Paulo conference, see

Aracy Amaral, *Blaise Cendrars No Brazil e os Modernistas* (São Paulo, 1970), pp. 106–15.

39. Cendrars's early poem "Tour," of August 1913, has an internal dedication to Delaunay. See Blaise Cendrars, *Du Monde entier, Poésies complètes: 1912–1924*, preface by Paul Morand (Paris, 1967), pp. 71–73. Delaunay himself appropriated Cendrars's poetic format of "Easter in New York," written in April 1912. See Delaunay (note 32), p. 81.

40. Blaise Cendrars, extract from the conference "Le Contraste Simultané," São Paulo, Brazil, June 12, 1924, published in Blaise Cendrars, *Aujourd'hui* (Paris, 1931), pp. 135ff. A translated version may be found in Delaunay (note 32), pp. 174–75, and in Vreisen and Imdahl (note 24), pp. 28–29.

41. For a discussion of the problem of Fuhrmann's authorship of photographs in the Folkwang Auriga-Archiv, although Thalemann is not mentioned, see Volker Kahmen, *Ernst Fuhrmann* (Cologne, 1979), pp. 3, 8–9, 46, 51. Of Thalemann's career, little is known since few of her photographs bore her credit. Photographs with attached paper labels reading "Photo: Thalemann" were published as the work of Heinrich Hauser. Her photographs were probably also published under Fuhrmann's name, but he took no photographs himself. The Eiffel Tower photographs bear a paper label credit of: "Atelier: Thalemann/Berlin." Thalemann's daughter recollects that her mother's Berlin studio was destroyed during World War II. The best discussion of Ilse Bing's biography and career is published in Nancy C. Barret, *Ilse Bing: Three Decades of Photography* (New Orleans, 1985).

42. This photograph was reproduced in *Vu* 10 (May 23, 1928), p. 254.

43. For a detailed listing of publications and exhibitions in which Kertész's photographs appeared, see Sandra S. Phillips, David Travis, and Weston J. Naef, *André Kertész: Of Paris and New York*, exh. cat., Chicago, The Art Institute of Chicago and New York, The Metropolitan Museum of Art (1985), pp. 257–58, and 280–82.

44. Jean d'Erleich, "La Tour à quarante ans," *Vu* 63 (May 29, 1929), pp. 431–33.

45. Other than in the d'Erleich article in *Vu* (note 44), this photograph was reproduced in Jean d'Erleich, "40 Jahre Eiffelturm," *Münchner Illustrierte Presse* 19 (May 12, 1929), p. 433; *Art et Médecine* (Oct. 1931), frontis.; and André Kertész, *Paris vu par André Kertész*, text by Pierre Mac Orlan (Paris, 1934), unpag. It was exhibited in 1930 in "Das Lichtbild," Munich, and probably at the Julien Levy Gallery, New York, 1932 and 1937. See Phillips, Travis, and Naef (note 43), p. 268 for further information about this photograph.

46. Recently, however, a similar view with the attributed date of 1928 by Josef Breitenbach was published in Mark Holborn, *Josef Breitenbach* (New York, 1986), p. 44.

47. This photograph was neither exhibited nor reproduced until 1963. See Phillips, Travis, and Naef (note 43), pp. 30, 65, 127, 259, for further information about this photograph.

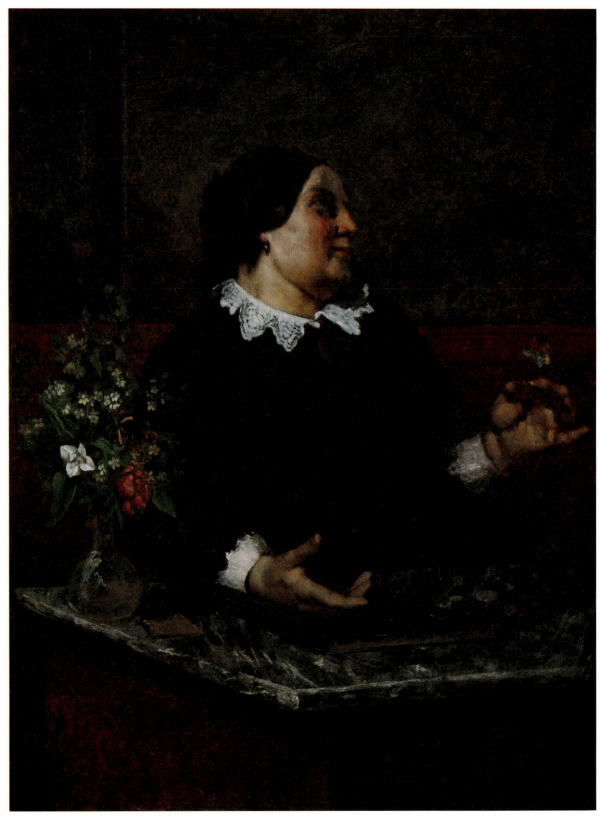

FIGURE 1. Gustave Courbet, (French, 1819–1877). *Mère Grégoire*, 1855/67. Oil on canvas, 129 × 97.5 cm. The Art Institute of Chicago, Wilson L. Mead Fund (1930.78).

Courbet's *Mère Grégoire* and Béranger

ROBERT L. HERBERT, *Yale University*

GUSTAVE COURBET'S *Mère Grégoire* (fig. 1), one of the glories of The Art Institute of Chicago, was based on the popular poem "Madame Grégoire" by Pierre Jean Béranger. That this has escaped notice until now owes principally to the fact that Béranger's chansons (poems set to popular airs) are not much read in the twentieth century. To explain Courbet's inspiration from the poet is to explain something of Béranger's importance as a popular writer in the middle of the nineteenth century and, even more, something of Courbet's conception of his art. First, it must be established that his painting does indeed derive from the Béranger poem, and then that *Mère Grégoire*, like so many of Courbet's works, raises fascinating social and political issues.[1]

Madame Grégoire

Air: It's Big Thomas.

It was during my days
That Madame Grégoire shone.
At the age of twenty I would go
To laugh and drink at her tavern;
She attracted people
With her engaging manner.
More than one brawny guy

Had credit there on his good looks.
Oh, how we'd go
And drink it up at her tavern!

Although she wept over the memory
Of a certain spouse,
None of us
Had known the late Grégoire;
But of replacing him
Who wouldn't have dreamed?
Happy was the table to which madam
Brought her bottle and her glass!
Oh, how we'd go
And drink it up at her tavern!

I can still see
Her laughing heartily until she cried,
And beneath her gold cross
The fullness of her modest charms.
Ask her lovers:
At the counter, the responsive brunette
Would give them double for their money.
Oh, how we'd go
And drink it up at her tavern!

The wives of coarse drinkers
Often picked quarrels with her.
How many times did I see
Suitors fighting over her!
While the doorkeeper and the lovers

Were always bickering,
She, a most clever woman,
Would hide the guilty ones in her bed.
Oh, how we would go
And drink it up at her tavern!

When it was my turn
To be master of her establishment,
Every day
Was a new feast for my friends.
I'm not the jealous type:
We worked things out for everyone.
Our hostess, pushing her sales,
Surrendered everything including the maid.
Oh, how we'd go
And drink it up at her tavern!

Everything has changed now:
Having nothing left to tap,
She took leave of
Both pleasure and business.
Alas, how I miss
Her wine cellar and her charms!
For a long time to come each customer
Will cry out in front of her place
Oh, how we'd go
And drink it up at her tavern![2]

Courbet's painting is a free improvisation based upon the personage of Madame Grégoire, with particular reference to the third stanza. Although she does not wear a golden cross, Courbet's woman has "a fullness of her modest charms," and "At the counter, the responsive brunette/would give them double for their money." The sense of this last verse, with its double-entendre, is at the very heart of Courbet's conception. The woman's right hand rests on her ledger, the palm upward in the traditional gesture of expectation of payment. Coins are on the counter in front of her, and the substantial, marble-topped counter bespeaks the proprietress (or, at least, the cashier) of the establishment. In Mère Grégoire's other hand is a flower, symbol of love, which she presumably offers to an unseen person to her left. This figure is standing, as we can deduce from Mère Grégoire's fixed gaze. Although we do not see him, we know him to be one of the favored customers who is fortunate enough to engage in the dialogue of money and love that Béranger's song celebrates.

The vase of flowers on the other side of the composition reinforces the gesture of love; a further reinforcement is found above, in the privacy screen (fig. 2) that stands behind the woman's bench. That it is indeed a privacy screen, and not part of a door or mirror, is clear in the original. The frame has brass nail heads or bosses, and the leather surface has a lozenge pattern stamped in gold.[3] Because it hints at a private space behind the counter, the screen takes its place in the compounded dialogue of the picture: money and love, public and private, man and woman, coin and flower, ledger and bouquet. Symbols of the dialectic may be carried even further. On the counter to the right is the kind of bell one rings for attention—an emblem of public function. On the left, near the vase, is a flat, grayish brown object (fig. 3) that seems to be either a small coin purse or the kind of pocket notebook in which one would record private debts or assignations.

Almost every feature of Courbet's painting, therefore, contributes to the characterization of Béranger's "Madame Grégoire." And, it should be noted that, contrary to the commonly held view of Courbet as vulgar and insensitive, he is revealed here as both discreet and subtle. Béranger's verses could easily give rise to any number of ribald interpretations, but Courbet did not

Far Left
FIGURE 2. Detail of *Mère Grégoire*
(figure 1).

Left
FIGURE 3. Detail of *Mère Grégoire*
(figure 1).

take such an easy route. The "fullness" of the cabaret owner's charms is indeed made "modest."

It is instructive to compare Courbet's interpretation with the only one so far found that precedes his: that of J. J. Grandville (fig. 4) for the 1836 edition of Béranger's poems.[4] Grandville's version, unlike Courbet's, shows us a favored client and, farther back, two customers. He represents Madame Grégoire—with the gold cross, hearty laugh, and modest charms cited in Béranger's third stanza—in the act of doling out coins. By comparison, Courbet's interpretation is very restrained. The restraint is only natural: Courbet's is an oil painting, requiring the autonomy and permanence of its medium, whereas Grandville's is an illustration, deliberately bordering upon caricature, that is attached directly to its text. (Despite the differences, it is likely, in view of his adaptation of Grandville's invention of the unseen client, that Courbet knew the Grandville illustration.)

Courbet's choice of Béranger's "Madame Grégoire" is particularly rich in political and social reverberations. To understand them, we need to look into the origins of

Béranger's poem and into his reputation in Courbet's day. Pierre Jean Béranger (1780–1857) was a native Parisian whose early reputation was based upon the chansons (the most famous being "Le Roi d'Yvetot") that circulated in Paris in the last years of the Empire.[5] Most of his poems were written and published between 1815 (when his first album was published) and 1833, after which he seldom wrote. A self-proclaimed "son of the people," he regarded himself as a spokesman of the ordinary Frenchman, who was the bearer of poetic and national energies. By 1821, Béranger was president of a singing society that congregated at Le Moulin Vert (also called Le Moulin de Beurre), one of the singing clubs (*goguettes*) that flowered under the Restoration. It was run by a woman called "Mère Saguet" who, according to Béranger's biographers, served as the model for "Madame Grégoire." Others who frequented her cabaret were the young Thiers, Armand Carrel, the artists Raffet and Charlet and, at various times, Hugo, Gautier, Gavarni, and Nerval. Like other singing societies, it was often a rallying point for opponents of current govern-

27

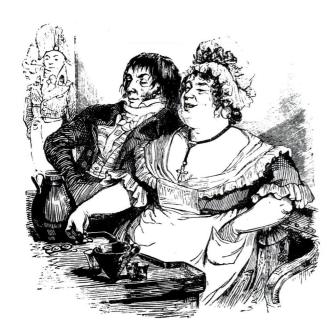

FIGURE 4. J. J. Grandville (French, 1803–1847). *Madame Grégoire* from Béranger, *Oeuvres complètes* (Paris, 1836).

ment, who couched their opposition in songs of witty double allusions that were designed to escape censorship.

From the singing societies of the 1820s to the revolutionary cafés and banquet societies of 1848, there was not a great distance, and we shall see that this evolution would logically take us also from Béranger to Courbet. The singing clubs and popular cafés were constant sources of agitation that were kept under surveillance— and often censored—by successive governments from 1820 onward. They bore a popular cachet, and some were truly working-class. Le Moulin Vert was apparently typical. When Mère Saguet retired in 1830,[6] her son-in-law, Bolay, allowed the establishment to become more openly political; it eventually became one of the many centers of opposition to the July Monarchy. Also, from 1830 onward, chansonniers became more numerous and more prominent, many of them taking their cues from Béranger. The admiration of left-wing literary and artistic circles gave increased prominence to worker-poets and worker-songwriters, and the frequent persecutions by the police heightened the social tensions that led to the 1848 Revolution. Because of its ostensible source in the people, the popular song, in the words of Pierre Brochon, became "the means of popular expression, par excellence" and, "by its form, its ease of diffusion among the semiliterate, it [was] the most efficacious method of propaganda, a veritable weapon."[7]

With the approach of 1848, the popular song became overtly political, and the chansonnier Pierre Dupont, a

disciple of Béranger, could subsequently claim that his songs had helped bring about the revolution.[8] Béranger, although he had virtually ceased writing, was by then a national figure and was especially popular among the ordinary citizens of Paris. This was true not only because of his songs, but also because of his standing as a victim of oppression. In 1821 and again in 1828, Béranger had been imprisoned for "outrage to religious and public morals and offense to the king."[9] The second imprisonment constituted a moral victory for the poet; famous people visited him in prison and liberal pamphleteers took up his defense. The incident helped make him the favorite of liberals such as Hugo, Lamartine, and Dumas the Elder. In 1848, Béranger was named to the Assembly in a genuinely popular movement, despite his protests that, approaching seventy and not concerned with politics, he was not a fit candidate.

Béranger was permitted to resign from the Assembly; he lived until 1857 in retirement, holding himself aloof from politics. New editions of his poems (1847, 1850, 1851, 1853, 1854, 1855) kept him before the public; he was such a national figure that he was widely viewed as a living La Fontaine.[10] His popularity led to homages that took many forms, including an album of songs, *Les Amours de Béranger*, published in 1854 by a number of admirers. His death in 1857 became a national event, in the wake of which there appeared a veritable outpouring of testimonials, songs, and vaudevilles drawn from his poems (five alone were put on stage in the autumn of 1857), and even a weekly journal, *Béranger*, which ran from September 1857 to February 1858.[11]

While all of this is true, it is equally important to recall that Béranger's last years were not at all free from polemic. Indeed, the interpretation of Courbet's *Mère Grégoire* is not possible without reference to Béranger's reputation. For one thing, while the poet had a broad popular appeal in the early 1850s, he was also the subject of strong attacks from both left and right. For the left, the republicanism of the elderly man was too moderate; his failure to denounce openly the regime of Louis Napoleon was a fatal flaw. For the right, his republicanism, the popular flavor of his poems, and his anti-clericalism all militated against him. Charles Augustin

Sainte-Beuve, once an admirer, attacked him in an essay in 1850 for being too vulgar, lacking chasteness, and favoring socialism.[12] Further to the right was Armand de Pontmartin, who attacked Béranger in *L'Opinion publique*, a legitimist journal, in the fall of 1851: Béranger was guilty of "criminal work" which appealed to "ill-bred libertines." Worse, in his poems, Béranger issued "a call to revolt" and engaged in "perpetual demolition of all the established authorities, the king, the magistrat, the priest."[13]

Attacks from the right like this were frequent and reached a high point in 1855 (the year Courbet assigned to his *Mère Grégoire*). De Pontmartin's article was reprinted in his book *Nouvelles Causeries littéraires*; his attack was seconded by that of another Catholic conservative, Louis Veuillot.[14] Although neither critic was enamored of Louis Napoleon, their assaults were sanctioned by his government's actions since 1851. Because the singing clubs and popular cafés, where Béranger's songs were sung, had been among the centers of agitation, they were suppressed in increasing numbers after the coup d'état. The researches of Susanna Barrows[15] have shown that, from 1851 to 1855, nearly 60,000 Parisian drinking establishments of all categories were shut down (dropping from approximately 350,000 to 291,000); further, we know that suppression and censorship led to the virtual elimination of open political references in popular songs and literature. Chansonniers were obliged to use well-disguised analogies, if they were to hint at politics at all.[16]

By 1855, the date given to *Mère Grégoire*, everything about Béranger would have conspired in favor of the painter's choice. Béranger was a notable "son of the people," widely admired by the shopkeepers and artisans of Paris with whom Courbet sympathized. The fact that "right-thinking" critics like de Pontmartin were attacking Béranger would be an additional reason for Courbet's admiration. Many of the attacks on the painter since 1850 had centered on the same qualities that Béranger was accused of having, and the government's suppression of popular cafés and drinking establishments would have fortified the painter's association of himself with the popular poet.

In fact, Courbet's *Mère Grégoire* should probably be seen as a protest—albeit a covert one—against censorship and, by extension, against government authority. Béranger had twice been imprisoned and, since the facts of the life of this popular hero were well known,

the very choice of *Madame Grégoire* by a notorious radical could be construed as an attack on censorship. There is abundant evidence that, as the Second Empire grew in power, the government forced writers of plays, songs, and vaudeville to find indirect means of opposing authority.[17] Courbet's *Mère Grégoire* would therefore seem to conform to a widespread pattern.

Why is *Mère Grégoire* so appropriate a selection from Béranger if the painter was thinking of his confrontations with authority? Any evocation of Béranger, after all, could be considered a satisfactory provocation. The answer is that *Mère Grégoire* was probably the kind of document that frequently is found in the history of art, namely, one that elicited an instinctive, subjective response in the artist, and yet one that had social portent. (Dogmatists are wrong in always opposing the subjective and the social.) Béranger's song is a particularly striking instance of the bawdiness in which Courbet indulged himself.[18] Its ribald character, its heroine who is frank and free in her loves, its celebration of drinking and conviviality, its disrespect for conventional morality— all its leading features were admirably suited to the robust artist who held forth in the Brasserie Andler, and who prided himself on his earthiness. Moreover, Courbet was proud of his musical talents and even composed some songs.

The social significance of *Mère Grégoire* stems from these same characteristics, transformed by the pressures of current history. This poem inevitably evoked the singing societies and popular cafés that had been powerful centers of opposition, and whose control had been specifically envisaged in a repressive decree of December 29, 1851.[19] There is even a serious temptation to believe that Courbet was consciously baiting the government in one feature of his painting. The flower that Mère Grégoire holds in her hand has not yet been identified but, unlike any real blossom, it carries the three colors of the French flag: red, white, and blue. If this was a conscious act, Courbet would have been setting the true Frenchness of Béranger against the usurped authority of the government he detested.[20]

If Courbet had exhibited *Mère Grégoire* in 1855, reaction to it might have provided a test of what has so far been stated here. He did not, however, and the truth is that the final judgment of the significance of the homage to Béranger rests on several confusing features of this painting's history. These are the traditional identification of the woman as Madame Andler, the date of the picture,

29

and its alteration (the canvas consists of two different pieces). Each of these must be dealt with in turn.

The painting, at least since Georges Riat's monograph on Courbet of 1906,[21] has been said to represent Madame Andler, proprietress of the brasserie that Courbet frequented from 1849 onward. This identification should be discarded. The first documented reference to Madame Andler dates well after Courbet's death, in the memoirs of his friend Alexandre Schanne, published in 1886.[22] All subsequent references stem from this one, including Riat's in 1906 and Charles Léger's in 1929.[23] Schanne is probably guilty, as are many writers of memoirs, of conjoining several reminiscences of earlier days into an unwitting invention.[24] Because the painting was mentioned by several of Courbet's acquaintances and friends during his lifetime (Silvestre, Thoré, Astruc, Castagnary, Etienne Baudry, etc.), it is logical to assume that one of them, at least, would have mentioned Madame Andler. When Castagnary and Baudry discovered the painting in a dealer's shop in 1873 (it had been stolen from storage in 1871),[25] and subsequently wrote to Courbet about it, surely they would have made some references to Madame Andler had she been the subject of the portrait. Moreover, Schanne was inconsistent because he noted that Madame Andler was hardly a sensualist: a student with a girlfriend had to endure "the fire of the angry glare of the owner."[26] This character hardly accords with *Mère Grégoire*, unless Courbet was deliberately mocking Madame Andler.

The possibility that Courbet was insulting Madame Andler by presenting her as the libertine Madame Grégoire should at least be mentioned, since it would have been well within the artist's known capacities. However, beginning in 1855, he had a long, bitter dispute with Madame Andler and her husband over payment of his debts; it was not resolved until 1869. That being so, it is not very likely that Courbet would have taken public revenge by exhibiting Madame Andler's painting in 1867, at the risk of her denouncing him. Furthermore, were he to have done so, the well-known dispute would have led some observers, at least, to invoke her name. However, it is logical to assume that the painting, done without Madame Andler in mind, could subsequently have been associated with her in Courbet's circle. Since Courbet's argument with her centered on money, *Mère Grégoire's* ledger could have inspired an ex post facto association as a way of insulting her. Perhaps this kind of teasing reference lay behind Schanne's erroneous assumption.

It is easier to believe that the lens of Schanne's memory was a bit obscured by time. The fame of Béranger's poem would have led him, and perhaps others, to make a connection between, on the one side, Béranger and the real Mère Saguet, proprietress of Le Moulin Vert and model of "Madame Grègoire," and, on the other, Courbet and Madame Andler. It is even reasonable to think that Courbet would have thought of the parallel between himself, leader of an informal society of drinking friends at the Brasserie Andler, and Béranger, the leader of the singing club at Mère Saguet's cabaret. Nonetheless, although one can readily imagine Madame Andler to have been the butt of more than one ribald joke, there is no reason to believe that she is the woman we see in Courbet's painting. It is more sensible to conclude that the woman is one of Courbet's models, a deduction endorsed by Hélène Toussaint.[27]

The problem of dating Courbet's painting is intimately linked with the fact that the head of the woman is on a separate piece of canvas, of coarser weave than the rest of the painting (see fig. 5).[28] When Castagnary and Baudry found it in 1873, Castagnary wrote Courbet: "O surprise! *Madame Grégoire*, whose head has been delicately severed, and then reinserted in the canvas. But the signs of the beheading have not yet been covered over."[29] This has sometimes been interpreted to mean that the painting was mutilated after it was stolen in 1871, and therefore that the head might not be that of the original composition. However, Courbet himself gave the explanation in a letter to Castagnary. "It is I who stuck the head of Mère Grégoire onto the large canvas, as usual, out of economy."[30] Castagnary would not have anticipated that; hence, his surprise in 1873 when the painting, having suffered some damage, exposed its piecing. The dealer, in this hypothesis, was trying to cover over the damage, but was not responsible for adding a new section of canvas.

This hypothesis is supported by all the evidence that we now have. The picture was first mentioned by Silvestre in 1856, in his *Histoire des artistes vivants*. In an often-cited passage, he wrote: "Recently I saw at his place the head of a sleepwalker or card dealer and another woman whom he calls *Madame Grégoire*, whose hideousness would rout witches and dwarfs that Shakespeare and Velazquez sometimes used as repoussoirs in their vigorous creations."[31] When we add his other reference to the painting, usually overlooked, we see that it is only a *head* of *Madame Grégoire* that he saw. In his list

FIGURE 5. *Mère Grégoire* in the process of being restored, 1977.

of Courbet's works, he recorded: "—Head of a sleep-walker.—Head of Mme *Grégoire*.—Portrait of M. Gueymard, of the Opéra (unfinished)."[32] There is no way of knowing whether the head Silvestre saw is the piece of the Chicago canvas or the separate head of the same woman now in the Musée de Morlaix.[33] There is no way of knowing, either, whether Courbet inserted the head into a large, unused canvas, expanding it into the full composition, or whether he removed the head from an already finished composition and inserted the one we now see. In either case, Silvestre's account establishes that the piecing of the final canvas took place after he saw it, that is, after 1855–56 and before 1859, when it was described quite thoroughly by Zacharie Astruc in

his article "Les 14 Stations du Salon." Astruc recounted a visit to Courbet's studio, where he saw *Mère Grégoire*, among other pictures, apparently in the process of being painted: "powerful old gossip dressed in black, collar embroidered at the neck, ruffles. . . ."[34]

Courbet included *Mère Grégoire* in his retrospective of 1867 and dated it 1855 in the catalogue. The date probably derives from the head that Silvestre saw; that is, Courbet probably dated the composition by reference to its inception rather than to its completion. Although he listed it among his "studies and sketches," the painting was almost certainly completed. In Randon's 1867 caricature of the painting (fig. 6), the woman's head and collar are so close to those in the present picture that

MADAME GRÉGOIRE.

Est-ce que, par impossible, cette dame-aurait eu l'audace de se faire passer auprès de M. Courbet pour la *Mère Grégoire*, cette bonne et aimable commère à l'œil brillant, au teint fleuri, à la bouche riante, que nous connaissons tous?... Ah! cher et illustre maître! quelle erreur serait la vôtre!

Figure 6. Gilbert Randon (French, 1814–1884). *Caricature of "Mère Grégoire,"* Le Journal amusant, 1867. Photo: Charles Léger, *Courbet selon les caricatures et les images,* (Paris, 1920) p. 69.

it is safe to assume that the inserted piece was already there. This deduction is supported by the careful examination and restoration conducted in Chicago in 1977; the authenticity of both sections of the canvas is not to be doubted. We can be sure only of a date between 1855 and 1867 for *Mère Grégoire*, but palette and brushwork seem to suit the period of the middle 1850s for the whole.[35]

It would be comforting to the analysis of the painting as an homage to Béranger to prove that it was painted about 1855 for, as we have seen, this was the height of the conservative attacks upon the popular poet that might well have led Courbet to associate himself with him. Of course, Silvestre's witness account of 1856 points to the head entitled *Madame Grégoire*, therefore to Courbet's intention of doing a picture after the Béranger poem. However, the whole period from 1855 to 1867, for all its internal changes, was one of constant polemic concerning Béranger, and Courbet's gesture makes sense at any point in that era. When Béranger died in 1857, there was the outpouring of pro-Béranger publications and plays mentioned above. Louis Napoleon's government, anx-

ious to capitalize on the poet's fame, conducted state ceremonies in his honor, pretending that he had made peace with the Empire. Similarly, it was widely claimed that, before he died, Béranger had declared his allegiance to God. This supposed rallying to both church and state was later disproven, but, at the time, it was generally believed, to the point that some leftists assaulted the poet's memory.

Béranger was also kept in the public eye by the continued popularity of his poems; by the publication of his letters to various correspondents; by the appearance of numerous anthologies of his work; and by the various comic operas, plays, and vaudevilles that were based upon his songs. One of these latter was the comic operetta *Madame Grégoire* by the famous Eugène Scribe (collaborating with Henri Boisseaux and Antoine Louis Clapisson), which began its run at Paris's Théâtre Lyrique in February 1861.[36] The fact that Béranger's poem was very well known is obvious from the comment of one reviewer of the operetta: "*Madame Grégoire*, whose reputation for earthiness has, thanks to her cabaret, long been known, has furnished the MM. Scribe and Boisseaux the canvas of a joyous intrigue, half carnivalesque, half pompadour, upon which M. Clapisson has embroidered profusely with his habitual spirit his pleasant melodies."[37]

And, in 1867, when Courbet exhibited his painting, Randon, in the text accompanying his caricature, also gave witness to the widespread familiarity with Béranger's original, by which he judged Courbet's derivation: "MADAME GREGOIRE. Is it at all possible that this woman would have had the audacity to pass herself off to M. Courbet as *Mère Grégoire*, that good and amiable gossip of sparkling eye, ruddy complexion, and laughing mouth, the one we all know? . . . Ah! dear and illustrious master! What an error you have made!"[38]

Courbet's "error" had been to *reinterpret* Béranger, giving the stamp of a real cabaret mistress to a personage many wished to see only as a buxom, laughing, and amiable woman. She is, in Courbet's image, remote from the conventions of beauty, a woman whose ruddy features and self-conscious gesture give her a formidable

presence. Courbet has wrenched Béranger's figure out of the pleasant fiction of a song and made her as real as is possible in the illusions of art. And her reality was offensive to Silvestre and to many of Courbet's contemporaries precisely because of this lack of idealization, this reminder that the models and shopkeepers and ordinary people he preferred were not the middle-class or aristocratic beauties that most expected to find in "art."

Courbet's appreciation of Béranger was, in this sense, very well judged, more so than that of his friends Baudelaire, Champfleury (i.e., J.F.F. Husson-Fleury), or Pierre Joseph Proudhon. Baudelaire's sense of the elegant was offended by Béranger, whom he dismissed as vulgar and lacking real talent. Champfleury had more respect for the "national poet," but was hardly enthusiastic.[39] Proudhon did admire Béranger, it is true, and his analysis of the poet was published by Béranger's ardent defender, Arthur Arnould, in 1864, three years before Courbet's painting was shown in public.[40] He called Béranger "the premier French poet of the nineteenth century," but he said that this was owing to his being the bearer of an old tradition, not to any originality of his own. Proudhon's preference for ideas over sensations made him regret Béranger's "retrograde and licentious love," and he lamented the poet's inability to write epic poems or tragedies.

We cannot really know what Courbet thought of Béranger, except what we can deduce from *Mère Grégoire*. The qualities that Proudhon least liked—Béranger's sensuality and his love of the women and men of ordinary cabarets—are those that Courbet would have most appreciated. Courbet was a sensual and impulsive man, with a strong dose of anarchism that suited his egocentric temperament. As an artist, he was free to ignore the philosopher's demand for a "higher" form of idea than those in popular songs. As an independent, without attachment to a specific political credo, he was free to identify Béranger's quintessential Frenchness with "the people," from whom Béranger derived his art.

Courbet finished his life in exile, and it is a temptation to liken his appreciation of Béranger to that of many of France's most notable political exiles: Hugo, Blanc, Sue, Leroux, Ledru-Rollin, d'Angers, and Thoré. Their sense of nationhood tested, and perhaps exalted, by banishment, they did not begrudge Béranger his foibles, as did Baudelaire and Proudhon, but honored his achievement as a gift to France. Exiles of other countries, including Marx, Garibaldi, and Heine, also admired

Béranger. They and Courbet would probably have endorsed the words of Thoré, in his letter to Béranger that served as preface to his *Salon de 1845*:

You have proved well that there are no small subjects or little forms at all, only small artists; for genius alters the proportions of all things. You have taken the song and elevated it to the ode and the poem. You have taken beggars and made great philosophers of them. You have taken the demented and made them into seers. Writing about bottles and tavern keepers, or just about everything, you have reanimated the French spirit and evoked generous feelings of patriotism and Equality. You are, as Pierre Leroux had said, the son of that great generation of the end of the eighteenth century who made the Revolution. You are common man and philosopher, like Diderot and Voltaire, and like them, you have placed your poetry in the service of Humanity.[41]

NOTES

This is a revised version of "Courbet's 'Mère Grégoire' and Béranger," first published as one of a group of symposium papers in Klaus Gallwitz and Klaus Herding, ed., *Malerei und Theorie: Das Courbet-Colloquium 1979* (Frankfurt am Main, Stadtische Galerie im Stadelschen Kunstinstitut, 1980), pp. 75–89. For courteous and efficient arrangements at the time of the symposium in Frankfurt, I am indebted to Prof. Klaus Herding, Dr. Margaret Stuffmann, and Ingo Begall. In preparing the 1980 publications, I was substantially aided by Susan Wise, then Assistant Curator in the Department of European Painting at The Art Institute of Chicago. She shared with me all the information, photographs, and other documents in her possession. I also benefited from an exchange of correspondence with Hélène Toussaint following the symposium. We do not agree on many matters, but my interpretation has been partly shaped by her conjectures.

1. For Courbet's *Mère Grégoire*, the essential reading is as follows: Susan Wise, "La Mère Grégoire" in The Art Institute of Chicago, *European Portraits 1600–1900 in The Art Institute of Chicago*, exh. cat. (1978), pp. 74–77; Robert Fernier, *La Vie et l'oeuvre de Gustave Courbet*, 2 vols. (Paris/Lausanne, 1977–78), vol. 2, no. 167; Hélène Toussaint, "La Mère Grégoire," in Paris, Grand Palais, *Gustave Courbet*, exh. cat. (1977), no. 45; idem, "Le Réalisme de Courbet au service de la satire politique et de la propagande gouvernementale," *Bulletin de la Société de l'Histoire de l'Art Français* (Dec. 1, 1979 [i.e., 1980]), pp. 233–44.

2. Madame Grégoire

Air: C'est le gros Thomas.

C'était de mon temps
Que brillait madame Grégoire.
J'allais à vingt ans

Dans son cabaret rire et boire;
Elle attirait les gens
Par des airs engageants.
Plus d'un brun à large poitrine
Avait là crédit sur la mine.
Ah! comme on entrait
Boire à son cabaret!

D'un certain époux
Bien qu'elle pleurât la mémoire,
Personne de nous
N'avait connu défunt Grégoire;
Mais à le remplacer
Qui n'eût voulu penser?
Heureux l'écot où la commère
Apportrait sa pinte et son verre!
Ah! comme on entrait
Boire à son cabaret!

Je crois voir encor
Son gros rire aller jusqu'aux larmes,
Et sous sa croix d'or
L'ampleur de ses pudiques charmes.
Consultez ses amants:
Au comptoir la sensible brune
Leur rendait deux pièces pour une.
Ah! comme on entrait
Boire à son cabaret!

Des buveurs grivois
Les femmes lui cherchaient querelle.
Que j'ai vu de fois
Des galants se battre pour elle!
La garde et les amours
Se chamaillant toujours,
Elle, une femme des plus capables,
Dans son lit cachait les coupables.
Ah! comme on entrait
Boire à son cabaret!

Quand ce fut mon tour
D'être en tout le maître chez elle,
C'était chaque jour
Pour mes amis fête nouvelle.
Je ne suis point jaloux:
Nous nous arrangions tous.
L'hôtesse, poussant à la vente,
Nous livrait jusqu'à la servante.
Ah! comme on entrait
Boire à son cabaret!

Tout est bien changé:
N'ayant plus rien à mettre en perce,
Elle a pris congé
Et des plaisirs et du commerce.
Que je regrette, hélas!

Sa cave et ses appas!
Longtemps encor chaque pratique
S'écrira devant sa boutique:
Ah! comme on entrait
Boire à son cabaret!

Oeuvres complètes de P.-J. de Béranger (Paris, 1836). The poem is undated but is assumed to have been composed about 1820.

3. John Keefe, formerly Curator of Decorative Arts at the Art Institute, identified this object as, in all likelihood, a Spanish screen from Cordoba, popular in the nineteenth century (information communicated by Susan Wise). I am very grateful to Mr. Keefe and Ms. Wise for identifying the screen. Presumably, it was an old photograph that led Fernier (note 1) to identify it as a mirror. Mlle Toussaint, in her 1981 article (note 1), continues to believe it is a mirror, and uses its symbolism to aid her interpretation.

4. Grandville's illustration appeared also in the Brussels edition of *Oeuvres complètes* (1844). Born Jean Ignace Isidore Gérard (1803–1847), the artist preferred "J. J. Grandville"; it is the only name inscribed on his tomb.

5. For Béranger, the best source is the monumental study by Jean Touchard, *La Gloire de Béranger*, 2 vols. (Paris, 1968). One should also consult Pierre Brochon, *La Chanson française, I: Béranger et son temps* (Paris, 1956).

6. See Brochon (note 5), pp. 12ff, and Toussaint, "Le Réalisme de Courbet . . ." (note 1), p. 235.

7. Brochon (note 5), p. 21. See also Emile Bouvier, *La Bataille réaliste* (Paris, 1913).

8. *Chants et chansons*, 3 vols. (Paris, 1851 and 1853), vol. 1, author's preface, p. 6.

9. See Touchard (note 5), vol. 1, pp. 391–98, 412–35.

10. Jean François Millet is among those painters who based a work on a song by Béranger: "Les Etoiles filantes" of c. 1848/50 (Cardiff, National Museum of Wales).

11. See Touchard (note 5), vol. 2, pp. 357ff. and passim.

12. Arthur Arnould, *Béranger, ses amis, ses ennemis et ses critiques* (Paris, 1864), pp. 68ff.

13. Touchard (note 5), vol. 2, p. 315.

14. Arnould (note 12), pp. 160ff.

15. Susanna Barrows, "After the Commune: Alcoholism, Temperance and Literature in the Early Third Republic," in John Merriman, ed., *Consciousness and Class Experience in 19th-Century Europe* (New York, 1979), pp. 205–18.

16. Compare, for example, the tone of the first and the third volumes of Pierre Dupont's *Chants et Chansons* (Paris, 1851 and 1853).

17. Siegfried Kracauer, *Orpheus in Paris: Offenbach and the Paris of his Time* (London, 1938).

18. The rather special vulgarity of Béranger's poem is probably the reason for its omission in all English anthologies of his work. The fact that Courbet's is *Mère* and Béranger's is *Madame Grégoire* is of no significance. The two words are virtually interchangeable in this context and, in fact, are so interchanged by Castagnary, in his letter to Courbet of 1873 (see p. 30), and in Randon's text for his caricature of 1867 (see p. 32, fig. 6).

19. Barrows (note 15), p. 207.

20. Subsequent to my initial presentation of this observation in Frankfurt, Mlle Toussaint became convinced that the flower was indeed a symbol of the republic; but, by a complicated route, and convinced that the painting dates from 1849, she reached the conclusion that Courbet's intention was to satirize the republic, not the Empire. See Toussaint (note 1 [1981]), pp. 236–41. I am unable to accept her early date for the painting, nor can I follow her ingenious but finally unconvincing argument.

21. Georges Riat, *Gustave Courbet peintre* (Paris, 1906).

22. Alexandre Schanne, *Souvenirs de Schaunard* (Paris, 1886).

23. Charles Léger, *Courbet* (Paris, 1929), p. 41: "The painter reimburses in part what he owes Mme Andler for his keep, assuring that she will lose nothing by waiting, besides, he will do her portrait ("il fera son portrait"), for which two studies exist, under the name of *Mère Grégoire*." Wise (note 1) made the wrong deduction from this text, for the phrase "he will do her portrait" is articulated by Léger on his own behalf; he was not using indirect discourse to attribute the words to Courbet.

24. Gerstle Mack, *Gustave Courbet* (New York, 1951), p. 154, pointed out that Schanne confused Courbet's trips to Montpellier in 1857 and to Le Havre in 1859 by combining features of both excursions.

25. Riat (note 21), p. 366.

26. Schanne (note 22), p. 296.

27. Toussaint, "Le Réalisme de Courbet . . ." (note 1), p. 239. Mlle Toussaint convincingly identified the model as Henriette Bonion, represented in several of Courbet's paintings, including the small portrait of her in the Musée Fabre, Montpellier, which can now be identified with her and which closely resembles the woman in the Art Institute's painting.

28. I am very grateful to Susan Wise for transmitting to me the results of the restoration carried out in 1977 by Alfred Jakstas, then conservator at the Art Institute. Richard R. Brettell, Searle Curator of European Painting at the Art Institute, has pointed out to me that the pattern of cusping on the inserted piece indicates that it had been nailed on its own stretcher for as much as two years before it was incorporated into the larger canvas.

29. Riat (note 21), p. 366.

30. ("C'est moi qui aie collé la tête de la Mère Grégoire sur cette grande toile, toujours par économie.") Letter dated March 26, 1874, in the Cabinet des Estampes, Bibliothèque Nationale, Paris, cited by Toussaint, "Le Réalisme de Courbet . . ." (note 1), p. 244. Wise (note 1), unaware of this letter as was I, correctly raised doubts about the supposed mutilation of the picture by another hand.

31. Théophile Silvestre, *Histoire des artistes vivants* (Paris, 1856), p. 273.

32. Ibid., p. 278.

33. Fernier (note 1), no. 168 (48 × 39.5 cm) is clearly a study for the Chicago head. Another painting (ibid., no. 169), in the Petit Palais, Paris, is also said to be both Madame Andler and Mère Grégoire, but bears no resemblance to the Chicago or the Morlaix pictures. See also note 27.

34. In the review *Le Quart d'Heure*, July 20, 1859, cited by Riat (note 21), p. 173.

35. This is despite the view of Mlle Toussaint, "Le Réalisme de Courbet . . ." (note 1), who wishes to place the picture very early, about 1848/49.

36. It was not the first, nor the last, musical work inspired by "Madame Grégoire." In May 1830, Rochefort, Dupeuty, and de Livry had put on a vaudeville piece, *Madame Grégoire ou le cabaret de la pomme de pin*. Exactly fifty years later, at the Menus Plaisirs in Paris, a musical play called *Madame Grégoire* was presented by Burani, Ordonneau, and Okolowicz. Touchard (note 5), vol. 2, pp. 638ff., showed that throughout Courbet's years in Paris, there was on the average more than one public presentation each year drawn from Béranger's songs.

37. *Moniteur des arts* 151 (Feb. 23, 1861), kindly communicated by Mlle Toussaint.

38. "Madame Grégoire" remained in the popular consciousness until the end of the century, when she was displaced by other favorites. In 1879, for example, a frequent visitor to Paris evoked Béranger to recall the old times he feared were lost: "You fancied that the bonny buxom hostess sitting behind the counter was 'Madame Grégoire'; that it was the 'Petit Homme Gris' who had just ordered another pint and that it was the 'Gros Roger Bontemps' who was playing at *tonneaux* [a game played with barrels] in the garden with Lisette"; see George Augustus Sala, *Paris Herself Again in 1878–9* (London, 1879), vol. 2, p. 6.

39. For the views of these and other contemporaries, see Touchard (note 5), vol. 2, pp. 394ff. Touchard paid very little attention to Proudhon, for reasons that are not clear.

40. Arnould (note 12), pp. 257–96. Arnould reprinted extensive passages from the suppressed *De la Justice dans la Revolution et dans l'Eglise*, on the grounds that those passages had not raised the censors' ire. Proudhon scholars seem to have overlooked this publication.

41. Théophile Thoré, *Salon de 1845, précédé d'une lettre à Bèranger* (Paris, 1845), pp. xxii-xxiii.

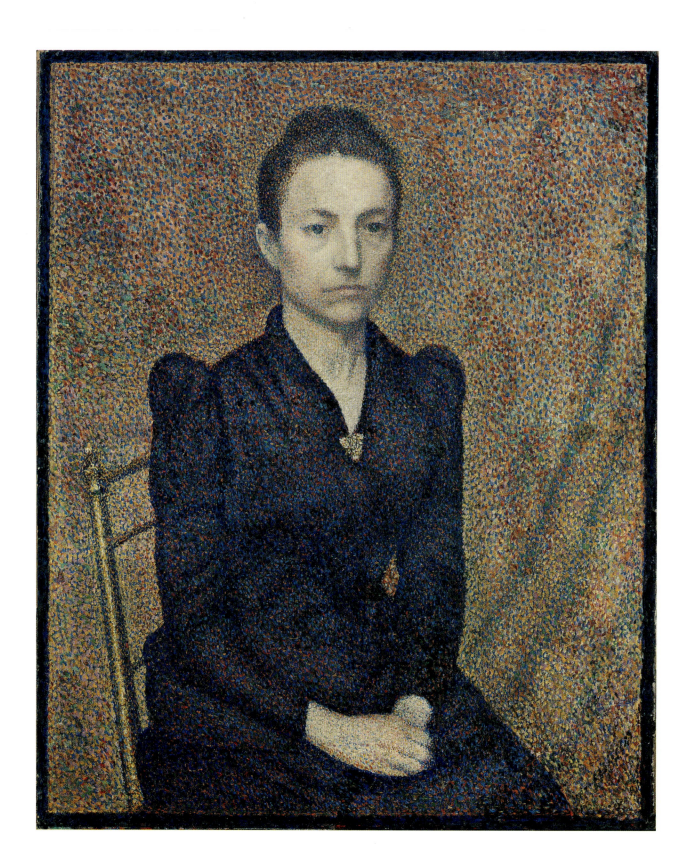

A Study in Belgian Neo-Impressionist Portraiture

JANE BLOCK, *Princeton University*

PORTRAIT OF THE ARTIST'S SISTER (fig. 1) by the Belgian artist Georges Lemmen (1865–1916) in The Art Institute of Chicago commands our attention for several important reasons.[1] The painting, dating from 1891, reveals the immediate and profound impact of the great French Neo-Impressionist Georges Seurat (1859–1891) on Belgian avant-garde artists. It exhibits the reductivist tendencies toward simplification and abstraction inherent in Neo-Impressionism combined with the Belgian artists' interest in portraying the sitter's psychological state, an aspect less developed in French examples. Finally, the canvas, carefully composed and masterfully executed, is a significant work within the oeuvre of the relatively little-known Georges Lemmen and a tribute to one of his earliest and most frequently employed models, his sister Julie.

Lemmen depicted his sister on numerous occasions and in a variety of domestic settings—crocheting (fig. 2), playing the parlor piano (fig. 3), or dressed for an outing (fig. 4). We need only compare these works to a photograph of Julie (fig. 5) to appreciate the accuracy of Lemmen's physical depiction. In all these paintings, he created a direct and unfiltered transcription of the "thin and angular features" of her physiognomy as remembered by the artist's daughter, Elisabeth Thevenin.[2] In addition to the physical resemblance it shares with Lemmen's other portraits of her, the Art Institute work also provides the most complete psychological portrait of Julie.

Thirteen years older than her brother, Julie Frédérique Lemmen (1852–1940) never married and lived with her parents in the family flat on rue Verte in Brussels, in the same building as the artist and his family. In contrast to the ideal Belgian woman of the late nineteenth century who was a loving

FIGURE 1. Georges Lemmen (Belgian, 1865–1916). *Portrait of the Artist's Sister*, 1891. Oil on canvas; 62 × 51 cm. The Art Institute of Chicago, A. A. McKay Fund (1961.42).

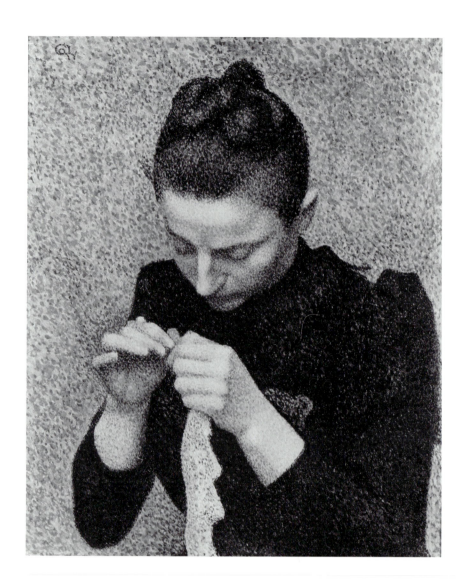

FIGURE 2. Georges Lemmen. *Aunt Julie*, c. 1891. Oil on canvas; 47 × 38.7 cm. Formerly Hirschl and Adler, New York. Photo: Hirschl and Adler.

wife and mother and mistress of her household, unmarried, dignified women such as Julie were restricted to the role of the understanding sister who performed subsidiary duties as nurse and nanny.[3] In addition to the domestic demands placed on Julie, she was forced to cater to the wishes of her strong-willed and long-lived mother. Julie's position in the family is graphically illustrated in a satirical sketch, humorously captioned in the language of the avant-garde, "La Famille Lemmen s'émancipe" (The Lemmen Family Escapes) (fig. 6). Lemmen showed Julie buffered and chaperoned by her mother and father on one side and by her uncle on the other. Lemmen rendered Julie rather uncompromisingly as a severe and unattractive creature, literally dwarfed by her family. Madame Thevenin recalled the strong contrast between her aunt's "very biting" personality in the company of adults and her congenial manner as nanny to Lemmen's children: "With my brothers and myself, whom she greatly loved, she did all that we wished—taught us games and told us stories."[4] In the Art Institute painting, Lemmen caught

FIGURE 4. Georges Lemmen. *The Visitor*, 1889. Oil on canvas; 68 × 53 cm. Brussels, S.N. Collection. Photo: © A.C.L. Brussels.

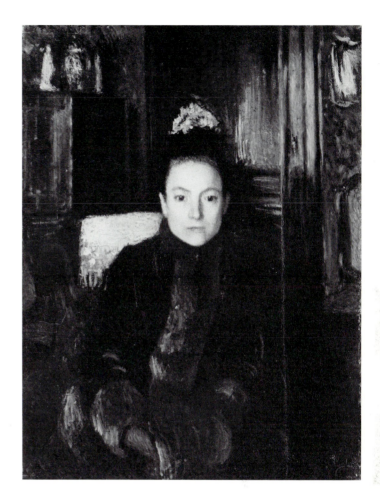

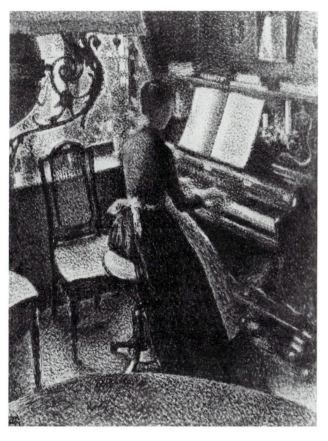

FIGURE 3. Georges Lemmen. *Woman Playing the Piano*, c. 1890. Conté crayon on paper; 56.5 × 43.5 cm. Brussels, Musées Royaux des Beaux-Arts de Belgique. Photo: © A.C.L. Brussels.

FIGURE 5. Photograph of Julie Lemmen (1852–1940), sister of Georges Lemmen. Date unknown. Brussels, Archives de l'art contemporain. Photo: E. Dulière, Brussels.

a considerable measure of the opposing forces of dependency and responsibility that pulled at his sister during most of her life. Here sits Julie, as fragile as a teacup, yet somehow impenetrable and indestructible.

Portrait of the Artist's Sister was created by the twenty-five-year-old Lemmen at the height of his Neo-Impressionist style.[5] Lemmen had turned to Neo-Impressionism in 1890 when he fell under the spell of Seurat. His early training at a local drawing school and his first exhibition at the triennial Salon of Ghent in 1883 had produced works in a realist vein.[6] One year later, the precocious Lemmen joined the progressive art club L'Essor and showed with it in 1884, 1885, and 1886. In these years of study and preparation, Lemmen sought to ally himself with the newer trends in his native Belgium. Two years later, with his election to the avant-garde artists' group Les XX (The Twenty), Lemmen was thrust into an international arena that sponsored the most radical exhibitions being held anywhere in Europe.

The exhibition society Les XX was composed of a core group of primarily Belgian artists who invited other Europeans and Americans of every stylistic persuasion to exhibit alongside them.[7] It provided a public forum for, in turn, the Impressionists, including Gustave Caillebotte, Mary Cassatt, Berthe Morisot, Claude Monet, and Auguste Renoir; in addition to Seurat, the Neo-Impressionists Paul Signac, Henri Edmond Cross, and Maximilien Luce; and Symbolists such as Odilon Redon, Paul Gauguin, and Maurice Denis. Les XX also featured the decorative arts, proudly displaying vases by Gauguin and Auguste Delaherche, an embroidery by Henry van de Velde, and folding screens by Emile Bernard and Anna Boch, the sole woman Vingtiste.[8]

Les XX was openly committed to the principle of newness in any artistic form. It hosted concerts and lectures in the very rooms in which the works of art were exhibited, sponsoring local and world premieres of compositions by César Franck, Gabriel Fauré, and Vincent d'Indy, as well as lectures by Stéphane Mallarmé and Paul Verlaine. Condemning old formulas as pastiches, Les XX supported "the bearers of the new" ("les apporteurs de neuf")—both at home and abroad. It was this devotion to the newest artistic vision, as well as a love of controversy, that led the organizers of Les XX to invite Seurat and the followers of his new style of painting to exhibit in Brussels.

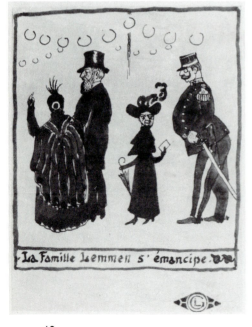

FIGURE 6. Georges Lemmen. *The Lemmen Family Escapes*, n.d. Pen and brush and ink on paper; 16 × 12 cm. Private collection. Photo: Sotheby's, London, sale cat. (Nov. 11, 1970), no. 9.

Although the term "Neo-Impressionism," first used by the French art critic Félix Fénéon, dates to 1886,[9] Seurat himself preferred the more scientific-sounding appellation "Chromo-luminarist," which emphasizes the importance of luminosity. Two other contemporary terms stress different aspects of the technique. "Divisionism" hints at how greater luminosity can be obtained through the separate application of strokes of paint according to a scientific division of color. "Pointillism" refers to the "points," or dots themselves, which, when recombined in the eye, produce the luminous image. However, only Fénéon's term, Neo-Impressionism, stresses the debt of these "new" Impressionists to their older predecessors such as Claude Monet and Auguste Renoir. While, like Seurat, the Impressionists were interested in increasing the luminosity of their paintings, they proceeded empirically to capture effects of light. Seurat, in contrast, sought to systematize his search for color and light in a rational manner. The Impressionists aimed at capturing fugitive aspects of nature, while Seurat and his followers strove to render the eternal underlying aspect of nature. The dichotomy between the instinctive technique of the Impressionists and the deliberate, objective vision of the Neo-Impressionists led Camille Pissarro to label these camps, respectively, "romantic" and "scientific" Impressionism.

Neo-Impressionism gained currency as a movement when Seurat, Signac, Camille Pissarro, and his son, Lucien, showed divisionist paintings at the eighth and last Impressionist exhibition in 1886. The uproar caused by Seurat's *Sunday Afternoon on the Island of La Grande Jatte* (fig. 7) at this show was not lost on Octave Maus, secretary of Les XX. Maus—lawyer,

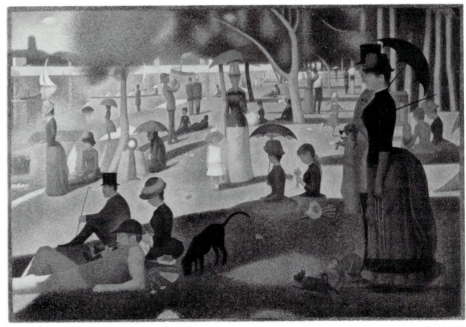

FIGURE 7. Georges Seurat (French, 1859–1891). *Sunday Afternoon on the Island of La Grande Jatte*, 1884–86. Oil on canvas; 207.6 × 308 cm. The Art Institute of Chicago, Helen Birch Bartlett Memorial Collection (1926.224).

FIGURE 8. "XX Frelaté" ("Les XX Adulterated"), cover of *Le Baton d'Chaise* 1, 9 (Jan. 6, 1889).

patron, and long-time supporter of Les XX—relished the opportunity to show the controversial painting in Brussels. In his weekly periodical *L'Art Moderne*, he anonymously reviewed the 1886 Impressionist exhibition in an article entitled "Les Vingtistes Parisiens," boldly claiming the French avant-garde as an extension of the Belgian vanguard.[10] Praising the radiance of the *Grande Jatte*, he called Seurat "the Messiah of a new art." He further added that, if the enormous canvas were shown in Brussels, it would cause a great scandal: "There would be . . . unexpected cases of mental derangement and fatal seizures." Both Seurat and Camille Pissarro were invited to show at Les XX's next exhibition, held in February 1887.

Maus also engaged Fénéon to become the Paris correspondent for *L'Art Moderne*, in order to explicate the Neo-Impressionist theory to a Belgian audience.[11] Fénéon's perceptive explanation of Pointillism and Maus's review predicting a hostile reception for the *Grande Jatte* in Brussels were conscious ploys by *L'Art Moderne* to temper the anticipated adverse criticism. Nonetheless, these prudent measures did not succeed in silencing the opposition. One critic claimed that Neo-Impressionism was a "school of gibberish applied to painting," and another that Seurat "was only a frantic reactionary, a purveyor of a paltry, narrow art without reach or value."[12] The pointillist dot was compared sacrilegeously to the communion wafer. Its infected adherents were branded *"les bubonistes"* (plague victims).

Allusions to the plague and, more generally, to contamination appeared in Brussels in numerous critical remarks and parodies. The satirical journal *Baton d'Chaise* spoofed Pointillism on its January 1889 cover (fig. 8). The caption, "XX frelaté," is a pun on the French homonym "vin frelaté" or "adulterated wine." Like the grotesque, bloated face of the image, the group Les XX had been tainted or contaminated by the French Neo-Impressionist import. Even three years later, the usually more serious *Patriote illustré* continued to stress the insalubriousness of the style (fig. 9). The ten frames satirize identifiable works shown at the 1892 Les XX exhibition, including such Neo-Impressionist portraits as Seurat's *Young Woman Powdering Herself* ("Mme Doctrine") (fig. 11) and Lemmen's *Mlle Maréchal* ("Mlle Gicogne"), a portrait of his future wife. The corrupted text below the dotted title, "Exposition des XX," purports to quote the high priest of symbolism, "Sâr" Péladan, concerning both the artists and their works: "Enlightened neuropaths, with cerebral incandescence . . . encrusted with a modernistic and rhythmic dot of polychromatic pustules."

The "enlightened neuropaths" at Les XX were represented not only by Seurat and his French Neo-Impressionist colleagues—Cross, Maximilien Luce, Signac (who became a Vingtiste in 1890), Camille and Lucien Pissarro, Charles Angrand, Louis Hayet, Léo Gausson, and Albert Dubois-Pillet—but also by the Belgian contingent. Lemmen was not the earliest Vingtiste to succumb to Neo-Impressionism. His friend Alfred (Willy) Finch produced

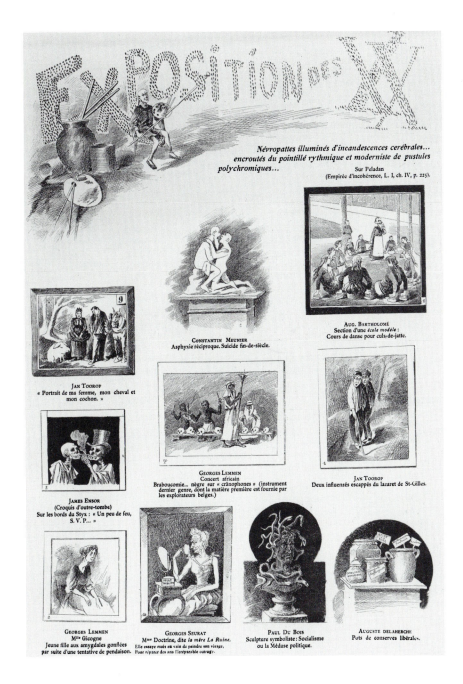

FIGURE 9. "Exposition des XX," *Le Patriote illustré*, no. 8 (Feb. 21, 1892), p. 19. Photo: © A.C.L., Brussels.

the first Belgian Pointillist drawing for the 1888 facsimile catalogue. Finch was soon joined by fellow Vingtistes Théo van Rysselberghe, van de Velde, Dario de Regoyos, Jan Toorop, and Lemmen.

It was through Les XX that Lemmen had the opportunity to become personally acquainted with Seurat. Although it is not known when the two artists first met, it is possible that they were introduced on February 2, 1887, when Seurat, accompanied by Signac, visited Brussels for the opening of the Les XX exhibition. Young Lemmen, referred to in print a month before as a "future Vingtiste," would certainly have wished to meet the creator of the

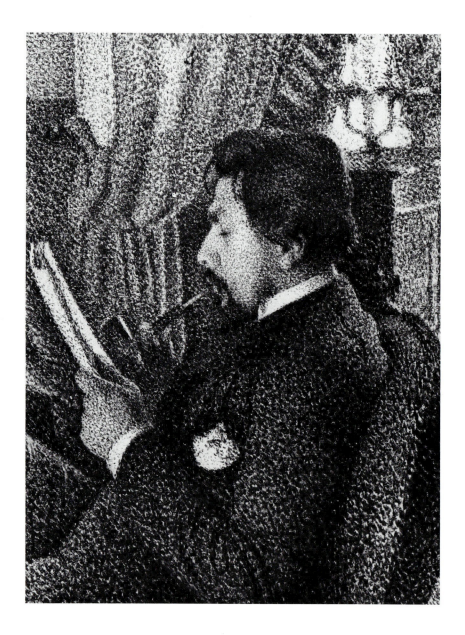

FIGURE 10. Georges Lemmen, *Portrait of Jan Toorop*, c. 1890. Conté crayon on paper; 53.5 × 39 cm. Bij Heino, Holland, Hannema-De Stuers Fundatie.

Grande Jatte, then on view.[13] Two years later, Seurat returned to Brussels for the second showing of his paintings and was a guest at the Vingtiste banquet held on the eve of the exhibition's opening on February 2.[14] Lemmen's association with Seurat became more than that of a remote, admiring disciple; rather, he developed a close personal rapport with the French artist. Only two days before Seurat's death, on March 27, 1891, Lemmen paid a final call to his friend. Much disturbed over Seurat's condition, Lemmen wrote to Signac that he found Seurat at home in bed, "racked by a high fever."[15] Lemmen acquired several drawings by Seurat that he lent to the 1892 memorial exhibition at Les XX.[16] Unfortunately, Lemmen became embroiled in a bitter dispute over the fair disposition of Seurat's oeuvre, which weakened his friendship with Signac.[17] Lemmen continued to paint in the

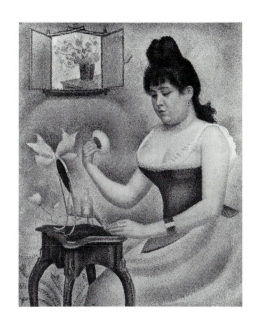

FIGURE 11. Georges Seurat. *Young Woman Powdering Herself*, 1889–90. Oil on canvas; 94.2 × 79.5 cm. London, Courtauld Institute Galleries (Courtauld Collection).

Divisionist manner, but his interest slackened after 1895. His admiration for Seurat, however, never faltered. A decade later, he wrote to Willy Finch about the problem of the Neo-Impressionist technique: "Ah! Seurat, on the other hand, was profound and alive . . . only Seurat knew how to master and soften it and make something of it, so that the technique was entirely forgotten and disappeared before the personality. . . ."[18]

In 1890, as a Neo-Impressionist adept, Lemmen was eager to apply the technique to a variety of subjects—seascapes, landscapes, and portraits. His Pointillist portraits consist almost exclusively of his family and such friends as the critic Emile Verhaeren and fellow artist Toorop (fig. 10). The ultimate source for Lemmen's portraits was Seurat's only major oil portrait, *Young Woman Powdering Herself* (fig. 11), shown in 1890 at the Paris Indépendants, an exhibition in which Lemmen also participated.[19] In addition to the general simplification and the treatment of objects as decorative, abstract shapes, the billowing pleats of Seurat's mistress's dress were directly repeated by Lemmen in the curtain folds behind both Julie and Toorop.

The new pictures of Julie differed greatly from those of only a year before. In 1889, two years before the Art Institute painting was completed, Lemmen had depicted Julie in a work that combines genre with portraiture (fig. 4). Swathed in a fur-trimmed coat and muff, surrounded by flowers and elements of still life, Julie portrays an afternoon caller. Lemmen's style here represents the Belgian equivalent of Impressionism, characterized by a palette much darker than that of his French Impressionist counterparts and a brushstroke that still defines rather than dissolves contour. The style and content of Lemmen's *Visitor* closely resembles that of his Belgian confreres Fernand Khnopff and James Ensor, who excelled in the depiction of women in domestic interiors charged with psychological nuance. Like Ensor's *Somber Lady* (fig. 12), Lemmen's painting focuses upon a solitary female figure who awaits an unknown and unspecific event about to unfold. The psychological malaise produced by an invisible, yet imminent, presence fulfills the Symbolist goal to suggest rather than state clearly, to express the ineffable and communicate the mystery of life.

Lemmen's portrayals of Julie after 1890 often retain either domestic elements in the action or the setting characteristic of contemporary genre painting. In a small canvas of around 1891 (fig. 2), Julie, with head bent, works in painstaking detail on a bit of Belgian lace, her great intensity height-

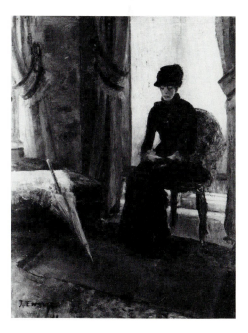

FIGURE 12. James Ensor (Belgian, 1860–1949). *Somber Lady*, 1881. Oil on canvas; 100 × 80 cm. Brussels, Musées royaux des Beaux-Arts de Belgique. Photo: © A.C.L., Brussels.

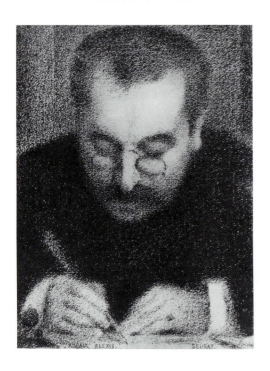

FIGURE 13. Georges Seurat. *Portrait of Paul Alexis*, 1888. Conté crayon on paper; 30 × 23 cm. Present whereabouts unknown. Photo: *La Vie Moderne* (June 17, 1888).

ened by Lemmen's elimination of any setting.[20] Again, as with the Art Institute painting, there is a precedent for this simplification in Seurat's work, particularly the drawing of Paul Alexis shown at the 1889 Les XX exhibition (fig. 13).[21] Lemmen elaborated on Seurat's representation of focused concentration to make Julie's prosaic gesture symbolic and ritualistic. The shaded face and downcast glance which lead to her highlighted fingers direct our attention to the action, not the personality, of the sitter.

The Art Institute portrait is close in style to this small canvas. Having experimented with reductivism in the painting of Julie crocheting, Lemmen seems to have been determined to do a full portrait of his sister in a similar manner. The Art Institute work returns to the larger size of the earlier *Visitor* and similarly treats Julie as a portrait, not as a genre subject. Gone are the outer garments and the still-life details. The comfortable armchair with antimacassar has been replaced by an armless brass chair.[22] Gone also is the pretense of the acted-out story. Julie, the maiden sister/nanny, sits erect in front of a curtained wall whose decoration is merely suggested. In this schema, Lemmen carefully stressed the silhouette of her form and costume. The rhythms are masterfully composed with the motif of her caplike, puffy shoulders repeated in the finial of the chair, her coiffure, and even the wall patterns. The triangular shape of her brooch is echoed in the space between Julie's bent left arm and her exposed neck. The softer, curvilinear folds at the right suggest a curtain and contrast with the rigid, rectilinear form of the chair.

Central to the construction of *Portrait of the Artist's Sister* are the principles of Neo-Impressionist color theory. Beyond the obvious use of individual dots of separate color, it is the particular colors selected that achieve the characteristic effect. The vibrancy created by the juxtaposition of complementary colors was long known to painters on an empirical level. However, Lemmen learned from Seurat and his coterie about Charles Henry's color wheel, which paired complementary hues in a categorical manner.[23] This theory produced two main Neo-Impressionist laws: those of "simultaneous contrast" and "successive contrast." Both are readily apparent in the Art Institute portrait of Julie. The former, activated when opposite colors are placed side by side, may be found in the sprinkle of subtle yellow dots placed in the predominantly purple field of the dress. The latter principle, which typically produced a halo effect, is most readily seen around Julie's hairline, where blue dots contrast with orange passages.

The Art Institute's Julie is one of a series of Lemmen's Neo-Impressionist portraits that culminated in the double portrait *The Serruys Sisters* (fig. 14).[24] The Art Institute is fortunate to have a preparatory study for this painting (fig. 15), a drawing that represents the older sister, Jenny, rendered in strict profile and wearing the same dress as in the oil. Lemmen carefully preserved the particular features of Jenny's physiognomy, as he did in the museum's portrait of Julie, and transferred them to the full composition. It is probable that Lemmen executed similar sketches for the Art Institute's portrait of Julie, although none has come to light.

The effect produced by the black-and-white drawing is similar to that of the colorful oil of the two sisters. Lemmen accomplished this by use of a

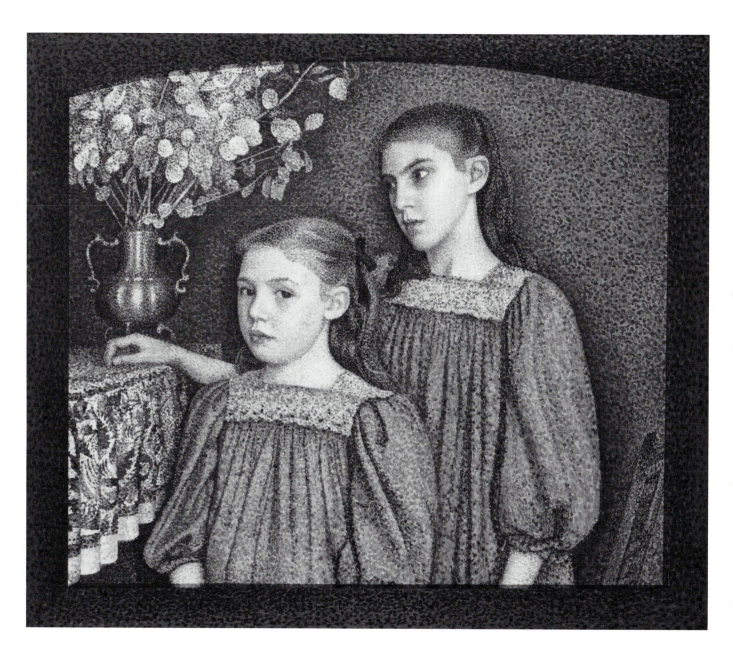

FIGURE 14. Georges Lemmen. *The Serruys
Sisters*, 1894. Oil on canvas; 60 × 70 cm.
Indianapolis Museum of Art, The Holliday
Collection (79.317). Photo: Robert Wallace,
Photographer, Indianapolis Museum of Art.

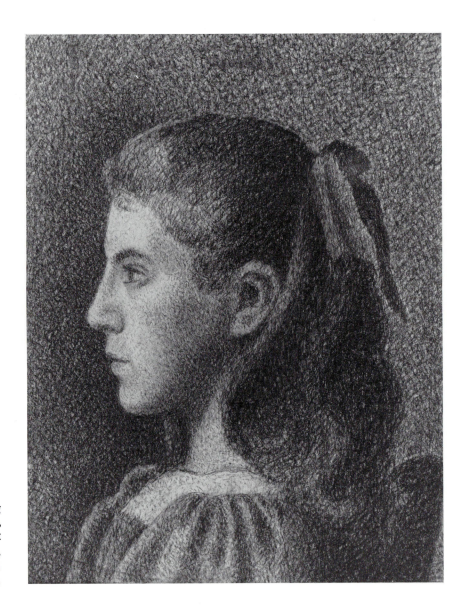

FIGURE 15. Georges Lemmen. *Young Girl* (study for *The Serruys Sisters*), 1894. Conté crayon on paper; 37 × 29 cm. The Art Institute of Chicago, Margaret Maw Blettner Memorial Collection (1982.1487).

cross-hatched stroke that activates the surface and in effect substitutes for the Neo-Impressionist dot. The strong contrast of areas containing both black and white in and around Jenny's face approximates the law of "successive contrast," producing the halo effect referred to above. This is achieved in the oil portrait of Jenny, as in the portrait of Julie, by contrasting two complementary colors, orange and blue.

Regardless of the medium, oil or drawing, Lemmen captured something of the spirit as well as the appearance of the sitter. The intensity of the fixed gaze of the Serruys sisters and Julie's penetrating eyes recall older, classical, and monumental prototypes in the Northern Renaissance tradition—those of Dürer and Holbein. Thus, beneath one of the most avant-garde styles of the day lies a time-honored conception of the portrait. The deliberate and painstaking working method that Neo-Impressionism required led Lemmen to search for models that bore the stamp of the eternal and the enduring.

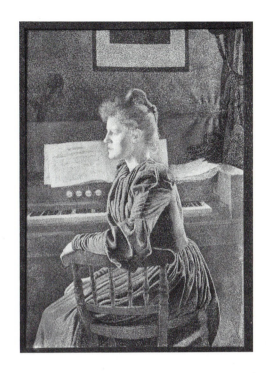

FIGURE 16. Théo van Rysselberghe (Belgian, 1862–1926). *Portrait of Maria van de Velde-Sèthe*, 1891. Oil on canvas; 118 × 84.5 cm. Antwerp, Koninklijk Museum voor Schone Kunsten. Photo: © A.C.L., Brussels.

Lemmen's portraits provide a marked contrast to those of the other major Belgian Neo-Impressionist figural painter, Théo van Rysselberghe (1862–1926). Unlike Lemmen's portrayal of Julie, van Rysselberghe's contemporaneous depiction of Maria Sèthe (fig. 16) shows the sitter in a milieu that expresses her cultural interests. The piano, cello, and framed work of art attest to the social attainment of the wealthy Sèthe family in general and of Maria in particular. In comparison, Lemmen focused not on the external cultural trappings of the sitter (elements that do often appear in his domestic sketches), but rather on Julie's internalized, introspective world. Even when he introduced a setting, it differs markedly from that in van Rysselberghe's work. In *The Serruys Sisters*, the elegant, patterned tablecloth and vase, with its shimmering, dried "silver dollars," create a sense of balance and activate the surface of the composition rather than define the two girls socially. Van Rysselberghe rendered form in plastic, sculptural terms. Lemmen's space in both paintings is shallow and two-dimensional. Maria—robust, hearty, and confident—sits in a deeper space with her arm appearing to jut out of the picture plane. The fragile Julie does not break the confines of her pose. Although van Rysselberghe invested the background with abstract swirling patterns of great energy, the overall effect remains illusionistic. On the other hand, Lemmen's patterning behind the sitter, while less noticeable, is constructionally more significant. Its gentle resonance echoes the motifs of her arms, shoulder puffs, and brooch.

Van Rysselberghe's interest in the sheer physicality of tangible objects and Maria's palpable presence focuses our attention on externals. Lemmen, with his deliberate reduction of still life and background detail and his stress on the thinness of the birdlike Julie, explored her internal life. In Seurat's portrait of his mistress, Maria Knoblock (fig. 11), his interest lay not in a direct re-creation of either the sitter's physical or psychological features. Rather, Seurat chose to stylize and abstract the sitter in the same way he treated the diminutive, Rococo vanity included with her. She is rendered not as a flesh-and-blood creature but as a vehicle for Neo-Impressionist theories. Lemmen's portraits are concerned with more than proportion, line, and color and ultimately transform Seurat's abstraction and reductivism into a means of focusing on a personality. Unlike Seurat's subject, a mannequin exquisitely fitted into abstracted surroundings, or van Rysselberghe's Maria, tellingly characterized by hers, Lemmen's portrait of his sister reduces setting to a minimum to produce a revelation of human psyche. Lemmen has presented Julie's internal state of mind as the picture's subject. We look not only at Julie, but into Julie, who serves to mirror our own psychological frailties and strengths.

NOTES

The author would like to thank Madame Elisabeth Thevenin, the artist's daughter, and her husband, the late Henri Thevenin, for their generosity and kindness; the Fulbright Commission for making possible this research; and the Archives de l'art contemporain of the Musées Royaux des Beaux-Arts de Belgique for access to invaluable documentation pertaining to Georges Lemmen.

1. This work was first exhibited under the title *"Mlle L"* at the Association pour l'art (Antwerp) in May 1892 and two months later at the Kunstkring, *Tentoonstilling van Schilderijen en teekeningen van eeningen uit de 'XX' de l'Association pour l'art* (The Hague). It appeared in Robert Herbert, *Neo-Impressionism*, exh. cat., New York, Solomon R. Guggenheim Museum (1968), p. 171, cat. no. 126; and most recently in The Brooklyn Museum, *Belgian Art 1880–1914*, exh. cat. (1980), no. 48. The painting was purchased by the Art Institute from the Allan Frumkin Gallery in 1961. The Art Institute's title, *Portrait of the Artist's Sister*, although descriptive, is clearly a modern and not an historical appellation.

2. Elisabeth Thevenin, letter to the author, Jan. 20, 1985. The physical and psychological portrait of Julie that follows was kindly provided by Mme Thevenin. In a previous letter, of Sept. 6, 1981, Mme Thevenin revealed that her father had a great affection for another sister, Laurence, who died at a young age.

3. For an interesting study concerning the position of women in Belgian society, see Georges H. Dumont and Jo Walgrave, *Vies des femmes, 1830–1980* (Brussels, 1980).

4. Elizabeth Thevenin, letter of Jan. 20, 1985 (note 2).

5. Lemmen is often included in surveys of Neo-Impressionist painting such as Robert Herbert (note 1); Jean Sutter, *The Neo-Impressionists* (Greenwich, Conn., 1970); and Ellen Lee, *The Aura of Neo-Impressionism: The W. J. Holliday Collection*, exh. cat., Indianapolis Museum of Art (1983). The sole monograph on Lemmen, Marcel Nyns, *Georges Lemmen* (Antwerp, 1954), is a slight survey of his career. In 1980, the Musée Horta in Brussels held a small show, and most recently (1984) the Galerij Ronny van de Velde & Co. (Antwerp) exhibited many of Lemmen's graphic works. The catalogue contains a notable essay by Roger Cardon, who is preparing a catalogue raisonné of Lemmen's etchings and lithographs. Johanna and Hedwig Ruyts-Van Rillaer of Leuven, Belgium, are preparing a catalogue raisonné of the paintings.

6. The author thanks Marc Alaert, Secrétaire of the Académie des Beaux-Arts de Saint Josse-ten-Noode, for verifying the dates of Lemmen's stay at this school (1881–83) and for providing the following information: during Lemmen's stint at the Académie, he won first prize in 1881 in the class of "têtes, torses et figures" (heads, torsos, and figures) and first prize again the following year in the class of "figure et nature" (human figure and nature).

7. Exhibitions were held annually in Brussels from 1884 to 1893, generally in February and March. For a brief survey of Les XX, see Jane Block, "Les XX: Forum of the Avant-Garde," in The Brooklyn Museum (note 1), pp. 17–40. For a more detailed discussion, see idem, *Les XX and Belgian Avant-Gardism, 1868–1894* (Ann Arbor, 1984).

8. The Les XX catalogues have been reprinted in one volume: *Les XX: catalogue des dix expositions annuelles* (Brussels, 1981).

9. See Félix Fénéon, "L'Impressionnisme aux Tuileries: correspondance particulière de l'Art Moderne," *L'Art Moderne* (Sept. 19, 1886), pp. 300–02. For more information on Fénéon, see Joan U. Halperin, ed., *Félix Fénéon and the Language of Art Criticism* (Ann Arbor, 1980).

10. [Octave Maus], "Les Vingtistes Parisiens," *L'Art Moderne* (June 27, 1886), pp. 201–04.

11. Fénéon's two earliest articles were: "L'Impressionnisme aux Tuileries" (note 9) and "Le Néo-impressionnisme: IIIᵉ Exposition de la Société des Artistes Indépendants," *L'Art Moderne* (May 1, 1887), pp. 73–76.

12. Le Huron, "Chronique bruxelloise," *La Nation*, Feb. 7, 1887; Georges Verdavainne, "L'Exposition des XX," *La Fédération Artistique* (Feb. 12, 1887), p. 136.

13. *La Wallonie* (Jan. 15, 1887), p. 69.

14. Seurat's work was shown at Les XX in 1887, 1889, 1890, and posthumously in 1892. Seurat listed Lemmen among the Vingtistes predisposed toward "optical painting." This document is reproduced in C. M. De Hauke, *Seurat et son oeuvre* (Paris, 1961), I, p. XX.

15. Letter from Lemmen to Signac, Mar. 31, 1891. The entire sentence reads: "He received me, but in bed, racked by a high fever, a cold, he said, that he caught at the exhibition" ("il m'attendait, mais au lit, accablé par une forte fièvre, un froid, me disait-il, pris à l'exposition"). Many thanks to Françoise Cachin for allowing the author to quote from the Signac archives in her possession.

16. These are listed as *Étude pour le Chahut* (cat. no. 27), *Étude pour la Parade* (cat. no. 28), and *Clair de lune* (cat. no. 29); see the 1981 reprint of *Les XX* (note 8), p. 269.

17. In Lemmen's letter of apology to Signac, dated June 29, 1891, Lemmen begged Signac not to resign his membership in Les XX over the misunderstanding (Signac archives). This quarrel is discussed in Guy Pogu, *Théo van Rysselberghe: sa vie* (Paris, 1963), pp. 10–16.

18. The letter is dated Mar. 26, 1903 (Archives de l'art contemporain, 21809/6–7, Musées Royaux des Beaux-Arts de Belgique, Brussels).

19. Lemmen exhibited at the Indépendants as early as 1889. In 1890, he showed a series of drawings of elephants which he identified as "Wombroell's [*sic*] ménagerie" (*Société des Artistes Indépendants* [Paris, 1890], p. 25, cat. nos. 474–77).

20. Lemmen showed this work in 1891 under the title "*Jeune femme faisant du crochet*" at both Les XX (see note 8, p. 236, cat. no. 2), and the Paris Indépendants (see note 19 [1891], p. 41, cat. no. 754). It was shown in 1959 at the Galerie André Maurice, Paris, as "*Tante Julie*" (cat. no. 21). The painting was purchased there by Hirschl and Adler Galleries, New York, and in the following year sold to a private collector; its present location is unknown. A small sketch for this work, dated Dec. 16, 1890, focuses on Julie's bent head and downcast eyes. Its whereabouts are also unknown.

21. Seurat treated a similar subject in his drawing of his mother sewing, 1882–83, The Metropolitan Museum of Art, New York. This work was shown at Les XX in 1892.

22. Madame Thevenin remembers this chair in the salon of her grandmother.

23. Lemmen humorously related an assignment given to him by Félix Fénéon: to transport a huge color wheel back to Brussels. Apparently, the wheel was destined for Gustave Kahn's (a French Symbolist poet) wife who was interested in trying her hand at Neo-Impressionist painting (letter from Lemmen to Signac, Apr. 14, 1891, Signac archives).

24. For a detailed discussion of this portrait, see Lee (note 5), pp. 44–47, where the sitters are identified and Neo-Impressionist color theory is explained in depth.

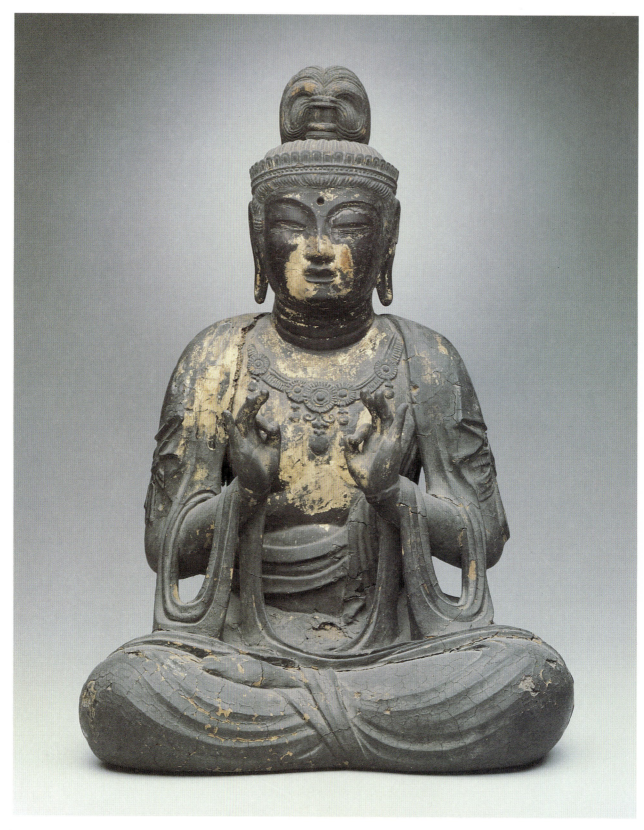

52

Japanese Sculpture in Transition:
An Eighth-Century Example from the
Tōdai-ji Buddhist Sculpture Workshop

by SAMUEL C. MORSE, *Amherst College*

T HE Buddhist Sculpture Workshop at Tōdai-ji
was the most influential sculpture atelier in Japan
during the second half of the eighth century. Tōdai-ji,
founded in the 740s by Emperor Shōmu (701–756;
r. 724–729), the forty-fifth ruler of Japan, remains today
one of the most important centers of Japanese Bud-
dhism. The temple, located in the early capital city of
Nara, is also a repository of countless works of art that
document its early history as an active center of state
Buddhism and the symbolic role the monastery later
played in the minds of the Japanese people. Many of
these important works were included in the exhibition
"The Great Eastern Temple: Treasures of Japanese Bud-
dhist Art from Tōdai-ji" held at The Art Institute of
Chicago in 1986.[1]

The eighth century was a period of great interna-
tionalism throughout East Asia, and Tōdai-ji was one of
a number of similar sanctuaries that exemplified a
close relationship between the Buddhist faith and the
state.[2] Emperor Shōmu conceived of the temple not only
as an expression of his own piety, but as the headquar-
ters of a national system of nunneries and monasteries.
His goal was two-fold: to spread Buddhist teachings
throughout Japan and to assert political control over the
Japanese state. The focal point of the sanctuary was a
colossal gilt-bronze image of Vairocana, the Cosmic
Buddha, housed in the Main Hall, which is said to be the
largest wooden structure in the world. Although twice
badly damaged by fires, this statue, known simply as the
Great Buddha, is the best known of all works of Japa-
nese Buddhist art.

Despite the tremendous size of the *Great Buddha*
(presently 14.73 meters in height, but originally about
one meter taller) and the complex technology required
to create it, the statue dates to early in the history of
Buddhist art in Japan. Until the introduction of Bud-
dhism in the late sixth century, Japan had no tradition of
monumental religious sculpture. In fact, the founding of
Tōdai-ji, the establishment of the extensive Buddhist
Sculpture Workshop on the temple grounds, and the
casting of the *Great Buddha* all took place only about
one-hundred and fifty years after the first Buddhist im-
age was made there. The styles of these early Japanese

FIGURE 1. Japanese. *Seated Bodhisattva*,
c. 775. Wood-core dry-lacquer, covered with
gold leaf; h. 60.5 cm. Nara, Tōdai-ji. The
Art Institute of Chicago (1962.356). All
works of art illustrated in this article are
Japanese, unless stated otherwise.

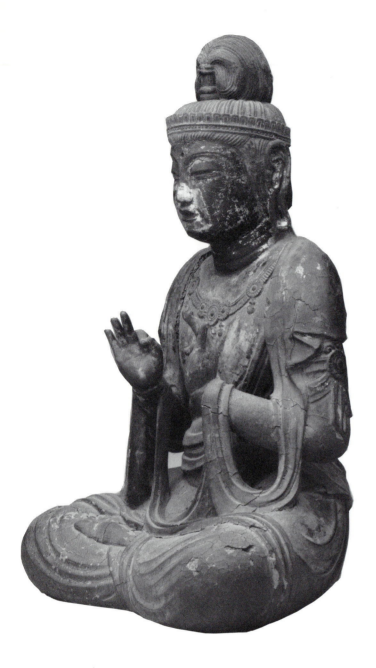

ture workshop at Tōdai-ji, which had dominated sculptural production in Nara for four decades, had been superseded by smaller, private ateliers more independent of government control. Coinciding with this change, and a direct result of declining financial support, was a shift in the materials of the Buddhist sculptor. Wood, which was inexpensive and readily available, replaced clay, bronze, and lacquer, which were costly and required time-consuming workshop production. An indirect, yet important, result of this shift in materials was a formal change as well—artists moved away from the idealized realism that had characterized the sculpture of the first half of the eighth century and developed more massive representations of Buddhist deities with full, brooding faces and highly mannered drapery.

Reflecting the beginning of this complex transition was the appearance in the 760s of works in what is known today as the wood-core dry-lacquer technique (see page 56, below). For a brief time, until the early years of the ninth century, this was used for many of the most important commissions in and around Nara. Wood-core dry-lacquer was employed almost ex-

FIGURE 2. Side view of *Seated Bodhisattva* (fig. 1).

FIGURE 3. Detail of Figure 1.

Buddhist statues of the seventh and eighth centuries were derived directly from China, as one style after another developed over five centuries on the continent and was imported and modified. By the time Tōdai-ji was founded, Japanese artists were working in styles and materials essentially contemporary with those in China.

During the forty years beginning with the completion of the *Great Buddha* at Tōdai-ji in 757, however, the nature of sculptural production in Japan underwent radical transformation. By the start of the Heian period (784–1185), the closely regulated, state-sponsored sculp-

FIGURE 4. *Thousand-armed Kannon*, c. 760. Hollow dry-lacquer, covered with gold leaf; h. 131.6 cm. Osaka Prefecture, Fujii-dera. Photo: Nagai Shin'ichi, ed., *Shitennō-ji to Kawachi no koji, Nihon koji bijutsu zenshū 7* (Tokyo, 1981), pl. 43.

clusively by artists working at the permanent, government-supported atelier at Tōdai-ji. Its adoption marks the first stage in the abandonment of the techniques, styles, and production methods of the high Tempyō period of the mid-eighth century, a time of state-sponsored Buddhism and fervent interest in China by members of the Nara court.

Japanese scholars have identified just over forty extant wood-core dry-lacquer works, many of which are badly damaged or in fragmentary condition.[3] All are thought to have been sculpted in the Nara region during the latter decades of the eighth and early years of the ninth century by artists trained at the Buddhist Sculpture Workshop at Tōdai-ji. Of these, only one completely intact work can be found in a collection outside of Japan: the small, finely crafted *Seated Bodhisattva* (figs. 1–3) in The Art Institute of Chicago.[4]

Seated in a stiff, frontal pose with its legs crossed and its hands held together at chest level, this *Seated Bodhisattva* is one of the finest examples of Japanese sculpture in the West. As is true with most wood-core dry-lacquer works sculpted between 760 and 800 by artists affiliated with the Buddhist Sculpture Workshop, this image derives many of its formal characteristics—the relatively realistic proportions of the body, the gracefully held fingers, and the fluid movements of the scarves which fall in undulating curves over the arms—from the naturalistic styles of the high Tempyō period.

On closer examination, however, it becomes evident that, despite these stylistic links with works of the mid-eighth century, a number of fundamental changes have occurred in the handling of the forms of the body and the drapery. When compared with the seated *Thousand-armed Kannon* at Fujii-dera (fig. 4), a hollow dry-lacquer work dating around 760, the change in style is readily apparent. For example, the plastic drapery folds on the shins of the Fujii-dera work have been replaced on the *Seated Bodhisattva* with much more schematic folds which, rather than alluding to real cloth, serve simply to emphasize the volumes of the underlying forms.

Coupled with a perceptible hardening of the planes of the face and a more volumetric treatment of the body, the formal characteristics of the Chicago statue reflect a definite movement away from mid-eighth-century styles and mark the approach of a sculptor with very different concerns.

More comparable to the Chicago *Bodhisattva* and somewhat better known is the left *Attendant Bodhisattva* (fig. 5) of the *Amida Triad* in the east bay of the Dempō-dō at Hōryū-ji. Although lacking the crown of the Chicago work and appearing less static due to its articulated post, the attendant at Hōryū-ji shares with the Chicago work a similar hard treatment of the facial surfaces and a fleshy upper torso. The artist draped his image with scarves that, like those on the Chicago *Bodhisattva*, delineate gentle, relaxed curves; however, the folds of the scarves are sharply carved and stylized, causing them to appear frozen in place. Both pieces reflect the gradual stylization of the modeling techniques of the first half of the Nara period.

As an isolated example from the late eighth century, the Chicago *Bodhisattva* would be worthy of study. What makes the statue particularly intriguing, however, is the existence of an image, designated *Miroku* (fig. 6) and also at Hōryū-ji, which is closely related in style and technique. Both the Art Institute and Hōryū-ji works have been conceived in stiff, frontal poses with the hands held in front of the volumetric bodies. The stylistic affinities between the two include the treatment of the tightly bound hair, the forms of the jewelry, and the

55

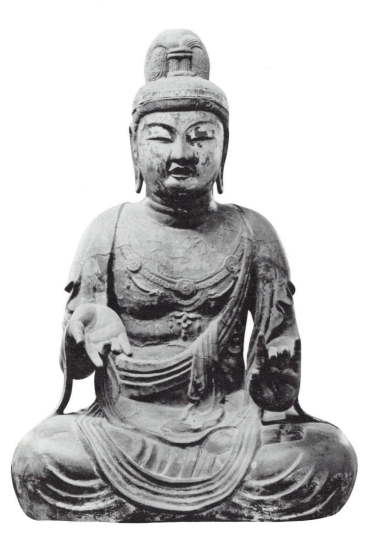

FIGURE 5. *Attendant Bodhisattva (Miroku)*, c. 770. Wood-core dry-lacquer covered with gold leaf; h. 126.5 cm. Nara Prefecture, Hōryū-ji, Dempō-dō.

fluid modeling of the pleats of the skirt.[5] The presence of the scarves on both works, sculpted in such a manner that they cover both shoulders and then cascade over the forearms and onto the lap in gentle curves, is so distinctive as to permit the hypothesis that the two statues were produced by the same artist or team of artists.

This conclusion is further strengthened by the fact that the two works were sculpted in the same variation of the wood-core dry-lacquer technique. In both works, the wooden core was fashioned out of a number of blocks of Japanese cypress (*hinoki*)—one for the head and torso, two for the legs, and two or three blocks for each arm—then carved to conform to a rough approximation of the final intended form. Next, the main block from both the base and the back was hollowed out, removing some of the wood to prevent the block from cracking as it dried. After the cavity in the back was covered with a board (the board presently on the Chicago sculpture is not original), the core was wrapped with a layer of lacquer-soaked linen cloth. The details of the surface were then modeled out of lacquer paste. On both statues, the layer of lacquer varies considerably in thickness. Where it is thick, such as on the jewelry or drapery folds, the paste determines the final form; where it is thin, such as on the arms or knees, the form is determined primarily by the carved core. On the hair above the crown and at the back of the head of each statue, no lacquer paste was used at all.

Dry lacquer was one of the most favored materials for sculpture in Japan throughout the Late Nara period (710–784).[6] In contrast to this relatively short period of popularity in Japan, the technique is known as early as the fourth century in China, where works continued to be made out of lacquer at least until the fourteenth century.[7] Although comparatively few Chinese lacquer works remain today, documentary evidence indicates that lacquer sculpture was particularly popular during the Tang dynasty (618–907). The technique must have been introduced to Japan sometime during the early decades of the eighth century, at a time when the vogue for Chinese culture was very strong among members of the Nara court.

During the first half of the eighth century, lacquer sculpture was made in what modern scholars call the hollow dry-lacquer (*dakkan kanshitsu*) technique. Representative of such works is the statue of *Sāriputra*, one of the *Ten Great Disciples of the Buddha*, dating to 734, in the collection of Kōfuku-ji in Nara (fig. 7). To create this figure, the sculptor first modeled the general form of

the monk out of clay mixed with rice chaff.[8] Over this core, he then wrapped a layer of linen cloth which had been soaked in lacquer. Once this initial layer of cloth had dried, the sculptor then proceeded to wrap up to seven or eight successive layers of lacquer-soaked cloth around the form. Since each layer had to dry completely before the next could be applied, the process took considerable time and each stage in the process required assistants with different technical skills.

After the final layer of cloth had dried, the artist sliced open the lacquer cylinder in order to remove the clay core. Into the resulting cavity, he inserted a simple bracing system to prevent the statue from warping. In the case of the *Sāriputra* and most others, the bracing system consisted of three or four flat pieces of wood cut to fit the shape of the cavity at the legs, waist, and shoulders (see fig. 8). These were held in place by a number of vertical struts which extended from the head and shoulders down to the feet. On some statues, such as the *Sāriputra*, simply carved cores for the arms were attached at the shoulders, while, on other works, they were left hollow.

Once the braces were in place, the artist sewed the lacquer cylinder back together with linen thread and wrapped the statue with another layer of lacquer-soaked cloth to hide the seam. He then modeled the details of the face, body, and robes with a paste made of lacquer, flour, threads, and powdered incense. For fingers and free-hanging scarves, he shaped the lacquer paste around wires. Finally, he sealed the entire surface with a thin layer of lacquer and finished the work with gold leaf or polychrome. Careful examination of the *Sāriputra* reveals the wood armature for the left arm and the wire armatures for the fingers of the left hand.

The primary advantage of lacquer as a material was that the finished work was easily transportable and insect-resistant. The major drawback was that the technique was costly, time-consuming, and necessitated workshop production. Consequently, during the latter decades of the eighth century, the sculptors working for the major temples in Nara devised a method that re-

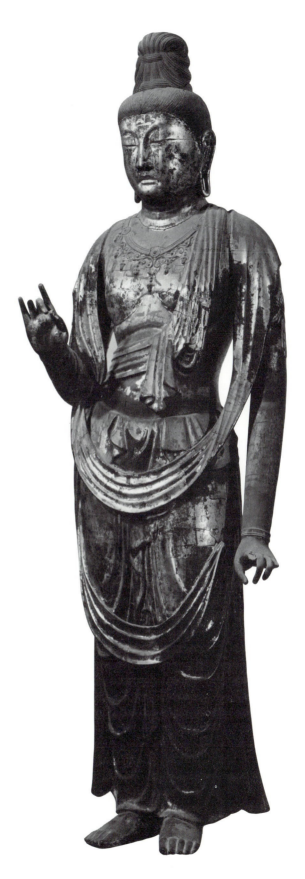

FIGURE 6. *Bodhisattva (Miroku)*, c. 775. Wood-core dry-lacquer covered with gold leaf; h. 62.4 cm. Nara Prefecture, Hōryū-ji, Dempō-dō. Photo: Nara rokudaiji taikan kankōkai, ed., *Hōryū-ji III, Nara rokudaiji taikan* 3 (Tokyo, 1969), pl. 225 (hereafter cited as *NRT*).

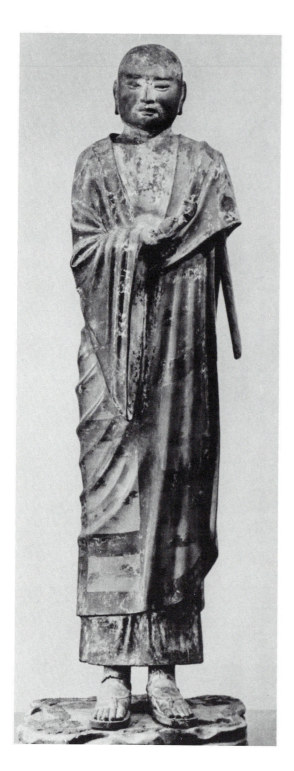

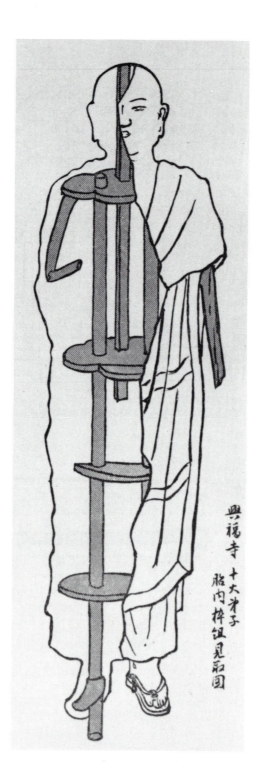

FIGURE 7. *Sāriputra* (one of the *Ten Great Disciples of the Buddha*), 734. Hollow dry-lacquer with polychrome; h. 154.8 cm. Nara, Kōfuku-ji. Photo: *Kōfuku-ji II*, *NRT 7*, pl. 168, right.

FIGURE 8. Diagram of internal bracing system of Figure 7. Photo: Myōchin Tsuneo, "Kōfuku-ji o shū toshita," *Tōyō bijutsu* (see note 8), p. 45.

placed the temporary clay core with a permanent wooden one. This is the wood-core dry-lacquer (*mokushin kanshitsu*) technique, the method used in sculpting the Art Institute's *Seated Bodhisattva*.

On a monumental *Head of Buddha* (fig. 9) at Tōshōdai-ji in Nara, much of the lacquer paste has fallen off, revealing the roughly carved wood core and allowing a clear understanding of this method of construction. After shaping the core with a chisel, the artist wrapped it with a single layer of lacquer-soaked linen cloth. Because he chose to carve the general forms of the facial features, he needed only a thin layer of lacquer paste to finish the forms. He sealed the completed statue with a final coat of liquid lacquer before gilding the entire work. On some works, the artists chose not to carve any details of the face at all, modeling them instead entirely from lacquer paste. On others, the artists did away completely with the layer of lacquer-soaked cloth. The numerous variations of the wood-core dry-lacquer technique provide direct evidence of the innovativeness of the artists of the Tōdai-ji Buddhist Sculpture Workshop, as well as illustrating their first attempts with a reductive method of sculptural production.

From its inception in 746 until it was closed by an imperial order in 789, the Office for the Construction of Tōdai-ji (*Zō Tōdai-ji shi*) was the major center of artistic activity in the Nara region.[9] Founded by Emperor Shōmu, the Office is best known for the *Great Buddha* project; however, artists working for the Office produced a large number of less well-known works, of which the Chicago *Bodhisattva* is a representative example. During the early years of its existence, the sculptors of the Office worked primarily in hollow dry-lacquer and clay, but, by the late 760s, they had abandoned those materials for the less costly wood-core dry-lacquer mode of production.

The Office for the Construction of Tōdai-ji was one of a number of similar institutions set up during the seventh and eighth centuries to oversee the construction and administration of temples.[10] Until the Office for Tōdai-ji was founded, offices for temple construction seem to have been temporary institutions in charge not only of building and image production, but of repairs and the copying of Buddhist texts as well.[11] Unlike its predecessors, the Office for the Construction of Tōdai-ji became a permanent institution in Nara.

For a seventeen-year period, from 746 to 763, the Office was responsible for the sculpting and casting of the *Great Buddha*, and the erection of the Great Buddha

Hall, the extensive monks' quarters that surrounded it, and all the other structures that were to comprise this vast monastic complex—pagodas, bell towers, and subsidiary halls such as the Nigatsu-dō and the Hokke-dō (a hall constructed on the grounds of the temple as a place for special readings of the *Lotus Sutra*). The construction and administration of all these structures, as well as the production of the paintings and sculptures

FIGURE 9. *Head of Buddha*, c. 780. Wood-core dry-lacquer; h. 80.4 cm. Nara, Tōshōdai-ji. Photo: *Tōshōdai-ji II*, *NRT* 13, pl. 57.

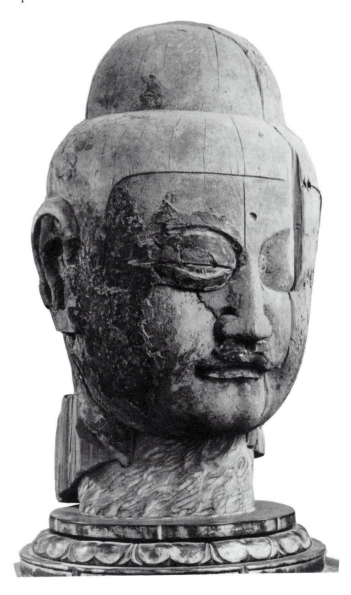

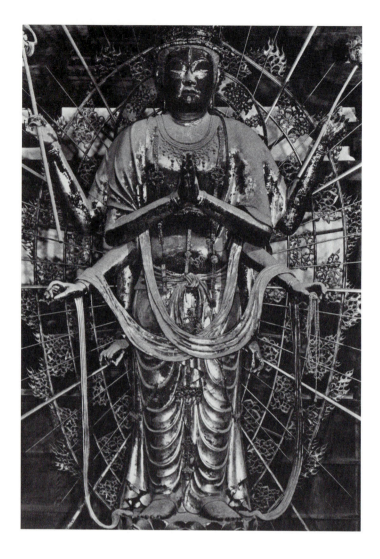

FIGURE 10. Kuninaka no Kimimaro (Japanese, died 774). *Fukūkensaku Kannon*, c. 748. Hollow dry-lacquer covered with gold leaf; h. 362 cm. Nara, Tōdai-ji, Hokke-dō. Photo: *Tōdai-ji II, NRT* 10, pl. 49.

kōjo), and the Tile Kiln (*Zōgajo*). Although the thirteen sculptors listed in contemporary documents as working in the Sculpture Workshop in the 750s did not comprise the greatest number of artists employed by the Office, they were clearly the most important group, responsible for producing not only the *Great Buddha*, but most of the lacquer sculpture made during the second half of the eighth century.[14]

Apart from preparations for the casting of the *Great Buddha*, the first project undertaken at Tōdai-ji by the artists of the Workshop was the sculpting of the hollow dry-lacquer images for the Hokke-dō. Reflecting the international high Tang style of the late seventh and early eighth centuries, these monumental statues were produced by Kuninaka no Kimimaro (died 774), the first Head of the Buddhist Sculpture Workshop (*Zōbutsu no kami*) and the artist of the *Great Buddha*. The focal point of the project was the eight-armed statue of *Fukūkensaku Kannon* (fig. 10), noteworthy not only for its imposing size, but also for its technical mastery of lacquer-sculpting techniques. The leading sculptor of his day, Kimimaro was equally adept in both lacquer and clay, but there is no evidence that, during the 740s and 750s, he or members of the Workshop used wood for anything other than pedestals or mandorlas.[15]

After the *Great Buddha* was completed, the Workshop, under Kimimaro's direction, undertook the attendant statues—the giant dry-lacquer bodhisattvas *Nyoirin* and *Kokūzō* and clay statues of the *Four Deva Kings*—which were finished in 752. One of the last statues to have been made for Tōdai-ji by the Workshop was a hollow dry-lacquer *Thousand-armed Kannon* for the Lecture Hall; it was commissioned by Shōmu's consort, Empress Kōmyō (701–760), in 756 and completed in the early 760s. In contrast with the statues in the Hokke-dō, made only ten years earlier, the arms of which were hollow like the torso, textual evidence indicates that the "thousand arms" of this statue were carved wood.[16]

Although the statue of Tōdai-ji is no longer extant, the seated *Thousand-armed Kannon* at Fujii-dera combines a hollow dry-lacquer body with numerous fully carved

housed in them, were the Office's responsibility. In contrast to the practices of the preceding century, the Office monopolized control over all government-sponsored Buddhist artistic activity throughout the Nara region.[12]

The Office, located somewhere on the vast grounds of the temple, was divided into three units: one in charge of copying Buddhist texts, one in charge of management, and one in charge of building and repairs (the largest of the three).[13] This last unit had two divisions, a permanent one on the grounds of Tōdai-ji and one made up of numerous temporary subdivisions at the temples being built throughout the region. The permanent unit was itself divided into a number of sections, the most important of which was the Buddhist Sculpture Workshop (*ZōBussho*). The other sections included the Painting Atelier (*Edokoro*), the Manufacturing Shop (*ZōButsujo*), the Foundry (*Idokoro*), the Woodworking Shop (*Mok-*

wooden arms. These two images mark the first recorded instances of completely carved wooden forms being used on statues produced by the Workshop, as well as the first stage in the adoption of wood as a sculptural medium by the artists based at Tōdai-ji. The relatively naturalistic proportions of the face and the fluid treatment of the drapery on the statue at Fujii-dera reflect the distinctive treatment of the artists of the Buddhist Sculpture Workshop and are reminiscent of the *Fukūkensaku Kannon* in the Hokke-dō at Tōdai-ji. The similarities between these two works is ample indication that the styles of lacquer sculpture produced at Tōdai-ji changed very little between the late 740s and the early 760s.

The first evidence of significant stylistic change is provided by one of the best known statues of the second half of the eighth century, the seated *Vairocana* (fig. 11) that is the main image of Tōshōdai-ji, a temple founded in 759 by Jian Zhen (689–763) (Japanese: Ganjin), a Chinese monk who had been invited to Japan by Shōmu. This statue is the finest extant monumental work in hollow dry-lacquer to have been produced by artists from the Tōdai-ji Workshop during the second half of the eighth century. The focus of ritual practice at the temple, the *Vairocana* must have been one of the first projects undertaken at Tōshōdai-ji after it was founded; the statue was most certainly completed before Jian Zhen's death in 763.[17]

Stylistically, many elements of the statue reflect the high Tempyō style of the Buddhist Sculpture Workshop. Most noteworthy is the treatment of the drapery folds which move over the body of the statue in a fluid and naturalistic manner. Moreover, there is a stability to the massive, well-proportioned body that places this image in the mainstream of eighth-century sculpture. The mastery of the hollow dry-lacquer technique reflected in this work, as well as the stylistic considerations described above, provides ample indication that, although Tōshōdai-ji was a semiautonomous temple, the statue was created with the active participation of accomplished artists from the Buddhist Sculpture Workshop at Tōdai-ji.[18]

At the same time that many of the formal qualities of the statue reflect the stylistic norms of the mid-eighth century, the *Vairocana* also provides crucial evidence for understanding the formal changes taking place in Buddhist imagery in Japan during the late eighth century.

FIGURE 11. *Vairocana*, c. 760. Hollow dry-lacquer covered with gold leaf; h. 304.5 cm. Nara, Tōshōdai-ji.

These changes are demonstrated in the oversized proportion of the head and massive body, and the brooding expression of the face dominated by the open, elongated eyes and down-turned mouth. Such exaggerated treatment is not present in early eighth-century works or in other contemporary works produced by the Workshop such as the *Thousand-armed Kannon* at Fujii-dera.

The sources of this formal change can only have been the Chinese styles introduced to Japan by the monks and sculptors who accompanied Jian Zhen on his journey to Japan and who resided at Tōshōdai-ji. A Chinese statue such as the *Seated Buddha* (fig. 12) in the collection of the Eisei Bunkō Foundation which is datable to the reign of Emperor Xuan Zong (713–756), resembles the *Vairocana* in the treatment of the massive volume of the body, the oversized head, and the full, fleshy cheeks.

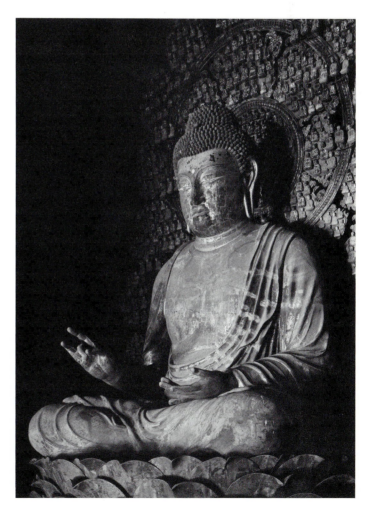

The most noticeable difference between the Japanese work and its continental prototype is in the former's more realistic treatment of the drapery, a trait that reflects the participation of artists from the Tōdai-ji Workshop.

Although Tōshōdai-ji received governmental support for the *Vairocana*, by the mid-760s, an independent atelier seems to have been established there by the Chinese artists who had accompanied Jian Zhen to Japan.[19] Those sculptors worked primarily in unpainted wood and in styles derived directly from the anti-idealizing styles current in China. Not only did this style of sculpture formulated at Tōshōdai-ji in the 760s exert a profound influence on the formal development of the Buddhist imagery of the early Heian period, but it also began to take hold among the sculptors of the Buddhist Sculpture Workshop during the 770s. The many wood-core dry-lacquer statues from the Nara region that combine the high Tempyō style with the formal qualities of mid-Tang-dynasty sculpture, works such as the Art Institute *Bodhisattva*, attest to this fact.

The shift from hollow to wood-core dry-lacquer is often explained as a direct reflection of the decreasing financial support by the government for temple construction projects during the latter decades of the eighth century. By the time the seated *Thousand-armed Kannon* for the Lecture Hall at Tōdai-ji had been completed in 762, the Office for the Construction of Tōdai-ji had become primarily involved with projects at other temples outside the capital, while responsibility for construction and repairs at Tōdai-ji itself shifted to members of the monastic community there.[20] One reason for this change was the deaths of Emperor Shōmu in 756 and of Empress Kōmyō in 760. Soon after Kōmyō died, the size of the Office for the Construction of Tōdai-ji was cut back as a means to reduce state expenditures on temple building.

As the government became progressively less involved in the affairs of Tōdai-ji, it provided the temple with less income as well. Evidence of this policy is a record concerning the sculpting of a clay *Kannon Triad* at Ishiyama-in (Ishiyama-dera) in Omi Province. In 762, the sculptor directing the project was requested to return to the Buddhist Sculpture Workshop because it was "very busy"; as a result, he did not receive a leave that year to work in the fields.[21] Moreover, two years earlier, due to a lack of manpower, the Workshop had to turn down a request to make over one-hundred statues.[22]

In the absence of documentary evidence detailing the activities of the sculptors at Tōdai-ji after the early 760s, the wood-core dry-lacquer statues of the 770s and 780s, such as the Chicago *Seated Bodhisattva*, provide vital evidence that the Workshop remained a major center of sculptural production until it was ultimately closed in 789. Searching for an alternative to the styles of the mid-eighth century, the sculptors took inspiration from the styles introduced at Tōshōdai-ji and gradually began to transform their works, producing statues with more volumetric bodies and more schematized drapery folds in the new technique.

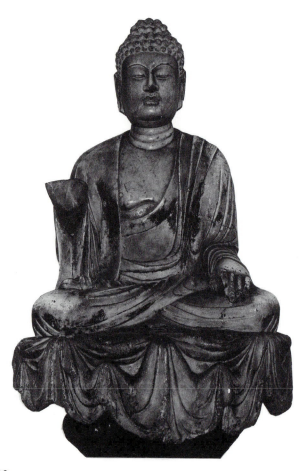

FIGURE 12. Chinese, Qinglong si, Changan. *Buddha*, c. 725. Marble; h. 73 cm. Tokyo, Eisei Bunkō Foundation. Photo: Matsubara Saburō, ed., *Chūgoku no bijutsu* (Kyoto, 1982), Vol. 1 (*chōkoku*), pl. 74.

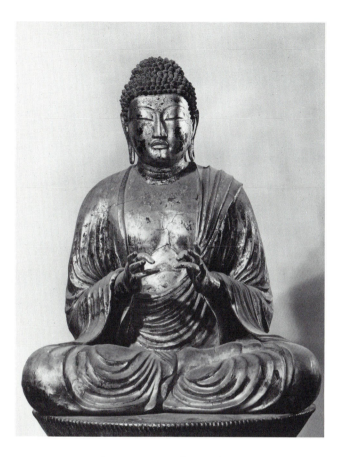

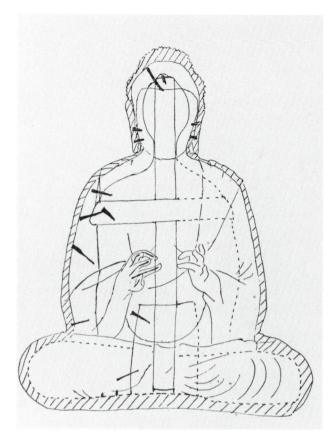

FIGURE 13. *Amida*, c. 770. Wood-core dry-lacquer covered with gold leaf; h. 87.7 cm. Nara Prefecture, Hōryū-ji, Dempō-dō.

FIGURE 14. Diagram of construction of Figure 13. Photo: Kuno, "Chōkoku" (see note 4), fig. 16.

In response to the lack of manpower and financial support for the Workshop's activities, it was only natural that the artists there would look for a less costly and less time-consuming method for producing their images. They found it in the wood-core dry-lacquer method, which they recognized as being better suited to this new mode of sculptural expression.

Although all works with modeled lacquer over a wooden armature are referred to as having been made in the wood-core dry-lacquer technique, the term does not take into account the variety of methods by which the cores were constructed. Technical analyses of wood-core dry-lacquer sculpture, using x-ray photography, have revealed that a number of different methods were used to produce the cores of the wood-core dry-lacquer images of the late eighth century.[23] By analyzing in depth the construction methods of wood-core dry-lacquer, it is possible to observe the experiments undertaken by the sculptors of the Workshop as they gradually abandoned the highly additive sculptural process of modeling dry-

lacquer for the reductive sculptural process of carving wood.

Like most of the wood-core dry-lacquer works of the 770s, the *Amida Triad* in the east bay of the Dempō-dō at Hōryū-ji (see fig. 13) clearly reflects the incorporation of the mid-eighth century Tang style with the idiom of the Tōdai-ji Workshop. The change is apparent in the full, exaggerated proportions of the body and in the image's severe expression. Nevertheless, the fluid treatment of the drapery on the chest, the naturalistic rendering of the hands, and the confident modeling of the lacquer on the surface clearly place this work within the tradition of the Buddhist Sculpture Workshop.

Of particular significance for understanding the process of the adoption of wood as the primary medium for sculpture in the early Heian period, however, is the manner in which the cores of the statues in the triad were formed (see fig. 14). The artist created the core of the *Amida* from a roughly hewn piece of wood split front and back and hollowed to a thickness of three cen-

timeters. To this, he attached a third block of wood to fill out the right shoulder and a fourth for the legs. Inside the cavity, the artist placed two pieces of wood as braces, one running from the top of the head to the base and the second between the two shoulders in a manner reminiscent of the bracing system on hollow dry-lacquer works. The cores of the *Attendant Bodhisattvas* (see fig. 5) were formed similarly, with two vertical braces running the length of the cavity in the torso and held in place by two horizontal struts at the shoulders and ankles. The artist proceeded to cover this wood core with a layer of lacquer paste up to three centimeters thick over the face and somewhat thinner over the rest of the work. None of the details seems to have been carved—both the facial features and the folds of the robe were modeled from the lacquer paste.

Technically, these statues represent the earliest experiments with a wood core by artists of the Buddhist Sculpture Workshop and the first step in the transition from hollow to wood-core dry-lacquer sculpture. Unsure as to whether or not a wood core covered with a thick layer of lacquer paste would warp, the artists added a simple bracing system not unlike those in hollow dry-lacquer statues.[24] Stylistically, this group represents an attempt to synthesize the somewhat naturalistic high Tempyō style with the more mannered high Tang styles, thus indicating a date in the early 770s.

Another group of works that exhibits a similar fusion of styles but that has what is called a joined wood-block core is the *Yakushi Triad* from Kōzan-ji (see fig. 15).[25] Although the drapery of the central image is treated in the high Tempyō style, the full volumes of the torso, the dour expression, and the bulging eyes—like those of the *Amida* at Dempō-dō—reflect a desire to incorporate within this style the volumetric, anti-idealizing manner introduced from China at Tōshōdai-ji.

The artist of this work seems to have realized that if he made the wood core thicker, he would no longer need an internal bracing system. The core of the *Yakushi*, for example, is made up of numerous blocks of wood which were joined together and roughly carved (see fig. 16). By using so many small blocks, the artist was able to assemble a core that was more complete than that of the *Amida*. Like the *Amida*, the entire surface is covered with a layer of lacquer paste out of which the artist modeled all the details. This layer of lacquer is considerably thinner, however—an indication that the artist realized that the more completely he formed the core, the

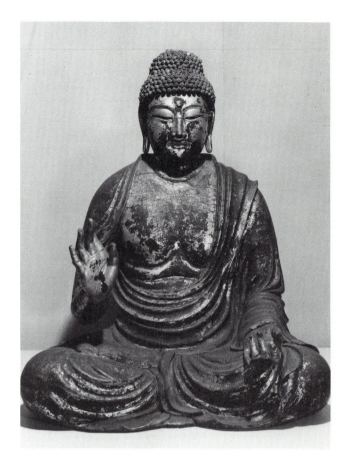

FIGURE 15. *Yakushi*, c. 775. Wood-core dry-lacquer covered with gold leaf; h. 73.6 cm. Kyoto, Kōzan-ji.

smaller the amount of costly lacquer he needed to complete his image.[26]

On many works, the artists replaced the multiple-block cores with cores that consisted of a single main block to which were added smaller blocks for the arms and, in the case of seated images, the legs. Representative of works produced in this manner are the Art Institute's *Seated Bodhisattva* and the standing *Eleven-headed Kannon* at Shōrin-ji in Nara Prefecture (fig. 17).[27] In a manner not unlike that used later in wood sculpture of the mid-ninth century, the main block that makes up the head, torso, and legs was hollowed from the back and front; the resulting cavity was covered with a board. Employing a relatively sophisticated joining technique, the artist formed the cores of each of the arms out of three separate pieces of wood which were subsequently attached to the wood core (see fig. 18); however, he did not carve any of the details of the face.

Finally, the entire image was covered with lacquer

64

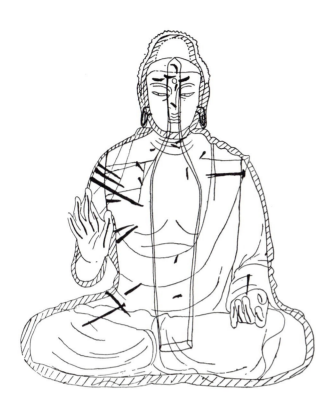

FIGURE 16. Diagram of construction of Figure 15. Photo: Kuno, "Chōkoku" (see note 4), fig. 21.

paste, up to twenty millimeters thick on the face but of almost negligible thickness along the bottom hem of the skirts.[28] This meant that the forms of the skirt's cascading folds were determined by the shape of the wood core, rather than by a modeled layer of lacquer paste.[29] With the appearance of this technical variation in the late 770s, the sculptors of the Tōdai-ji Workshop had reached a point just one step removed from working exclusively in wood.

What makes the *Seated Bodhisattva* in the collection of the Art Institute and the *Miroku* at Hōryū-ji particularly intriguing, however, is the presence of two other works in Japan that are essentially of the same size and that share many stylistic traits—a seated *Bodhisattva* said to be of Monju in the collection of Yakushi-ji (fig. 19), and a seated *Bodhisattva* said to be of Kokūzō and now in the collection of Nōman-ji in Fukushima Prefecture (fig. 20) but originally in the collection of Tōdai-ji.[30] Although different in some details from the

two statues discussed above, all four have similar proportions, share similar realistically modeled pleats on the skirt, and display a distinctive stylistic signature— scarves that closely cover the tops of the shoulders and then loop in gentle curves over the forearms and onto the chest.

Technically, the Nōman-ji statue and the Chicago *Bodhisattva* are similar as well. For example, the cores of both have been assembled and hollowed in almost exactly the same manner, which has led some scholars to consider the four a single group.[31] The major difference between the two is in the way in which the artist used the lacquer paste. In contrast to the Chicago work, where lacquer paste covers the entire surface and was used to model the final form of the facial features as well as the details of the robes and jewelry, paste was used exceedingly sparingly on the statue of Kokūzō; in fact, the entire face is carved wood.

This comparison of the *Seated Bodhisattva* in the collection of the Art Institute and the *Kokūzō* at Nōman-ji provides conclusive evidence that the sculptors at Tōdai-ji were gradually becoming more confident in working in wood during the 770s and 780s. As the carving skill of the sculptors increased, they discovered that they could carve more and more of the final form of their images out of wood, using lacquer only for details of drapery or jewelry. By carving the details of the face of his image before applying the layer of lacquer paste, the artist of the Art Institute's *Seated Bodhisattva* and the *Miroku* at Hōryū-ji moved one step closer to working in wood than the artist of the standing *Eleven-headed Kannon* at Shōrin-ji. The artist of the *Kokūzō* at Nōman-ji, working in a similar style, chose to abandon lacquer paste altogether for the focal point of his statue—the face. For both artists, the shift to working exclusively in wood must have been inevitable.

Most Japanese scholars dismiss wood-core dry-lacquer sculpture as simply a prelude to the six-hundred-year tradition of wood sculpture that began in the early ninth century. Those who have studied the period between 760 and 800 most often cite economic factors for the invention and widespread adoption of the wood-core dry-lacquer technique by sculptors working in Nara in the late eighth century. Although clearly a contributing factor, given the decline in government support for the Buddhist Sculpture Workshop at Tōdai-ji after 760, this explanation cannot account for the technical innovation and significant stylistic change that took place there dur-

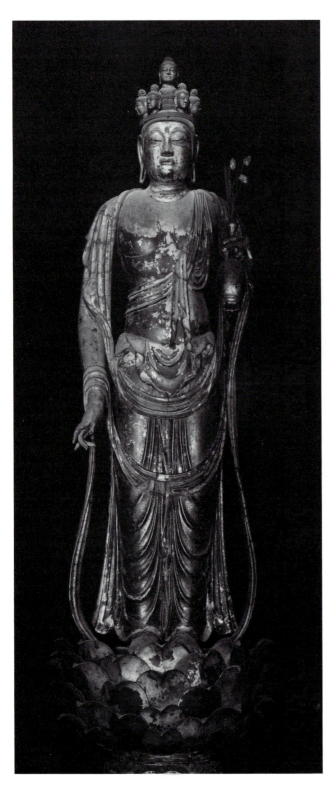

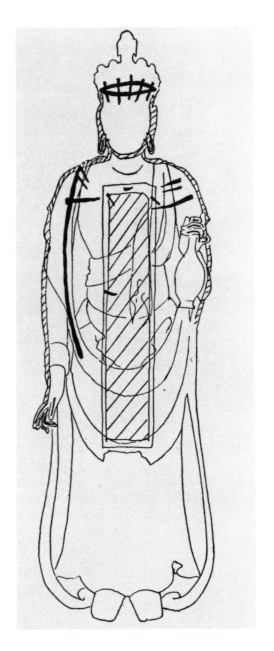

Above left
FIGURE 17. *Eleven-headed Kannon*, c. 775. Wood-core dry-lacquer covered with gold leaf; h. 209 cm. Nara Prefecture, Shōrin-ji.

Above right
FIGURE 18. Diagram of construction of Figure 17. Photo: Kuno, "Chōkoku" (see note 4), fig. 23.

ing the 770s and 780s. A more comprehensive analysis of the evolution of the wood-core dry-lacquer technique indicates that the sculptures at Tōdai-ji found the reductive technique of carving wood more suited to their new mode of sculptural expression. The style of sculpture formulated at the Buddhist Sculpture Workshop which synthesized the high Tempyō style with the more anti-idealizing styles introduced to Japan for the first time at Tōshōdai-ji became one of the dominant trends of sculpture throughout the early Heian period.[32]

The existence of four wood-core dry-lacquer *Bodhisattvas* from the late eighth century that share so many formal traits as to permit the assumption that they were produced by the same artist or by related artists would be remarkable in itself. What makes these statues of particular interest is that, as a group, they document transitions in style, technique, and methods of production that took place at the Tōdai-ji Buddhist Sculpture Workshop between the mid-eighth and early ninth centuries.

Above
FIGURE 19. *Bodhisattva (Monju)*, 775. Wood-core dry-lacquer covered with gold leaf; h. 62.5 cm. Nara, Yakushi-ji. Photo: *Yakushi-ji, NRT* 6, pl. 162.

Left
FIGURE 20. *Bodhisattva (Kokūzō)*, c. 775. Wood-core dry-lacquer covered with gold leaf; h. 62.5 cm. Fukushima Prefecture, Nōman-ji.

67

NOTES

The author would like to thank Yutaka Mino, Curator of Chinese and Japanese Art at the Art Institute, for his encouragement in this project. Also to be thanked for their insightful comments in the preparation of this article are John M. Rosenfield of Harvard University; Nishikawa Shinji, professor emeritus of Keio University; and Matsuura Masaaki of the Nara National Museum. Research for this article was generously supported by the Howard Foundation.

1. For an overview in English of Tōdai-ji, its architecture, sculpture, and painting, see The Art Institute of Chicago, *The Great Eastern Temple—Treasures of Japanese Buddhist Art from Tōdai-ji*, exh. cat. (Chicago, 1986).

2. For a discussion of the history of the temple, see John M. Rosenfield's introduction in The Art Institute of Chicago (note 1), pp. 17–31.

3. Because the late eighth century has traditionally been ignored by Japanese scholars in favor of the early Heian period, there are few studies on the sculpture of those years. Representative articles include Hirashi Shakurei, "Kyōchō zō kō," *Kokka* 249 (Feb. 1911), pp. 221–24; 251 (April 1911), pp. 278–83; Maruo Shōsaburō, "Nihon chōkokushi jō ni okeru mokuchō no tanjō," *Kokka* 388 (Aug. 1922), pp. 71–76; Homma Masayoshi, "Sōzō oyobi kanshitsu zō no seisaku to suichō ni taisuru ikkaishaku," *Bijutsushi* 5 (Jan. 1952), pp. 6–18; Kuno Takeshi, "Mokushin kanshitsu to Heian shoki chōkoku," *Bijutsu kenkyū* 171 (Nov. 1953), pp. 67–84. A slightly different perspective can be found in Asai Kazuharu, "Tempyō kōki mokushin kanshitsu zō no seiritsu," *Bijutsushi* 106 (Feb. 1979), pp. 103–26.

4. This work has been studied in depth only by Kuno Takeshi, formerly of the Tokyo National Research Institute, who examined its method of construction by means of x-ray photography (see also note 23). See Kuno Takeshi, "Chōkoku," in Tokyo kokuritsu bunkazai kenkyu han, ed., *Kōgaku teki hōhō ni yoru kobijutsuhin no kenkyū* (Tokyo, 1955), pp. 131–32. Kuno subsequently discussed the formal qualities of the work in an article written in 1960. See Kuno, "Bosatsu," *Kokka* 824 (Nov. 1960), pp. 444–49. More recently, the work was discussed briefly by Tanabe Saburōsuke in Nihon Art Center, ed., *Zaigai nihon no shihō, 8 Chōkoku* (Tokyo, 1980), p. 162.

5. The similarities between the two works were first noticed by Kuno Takeshi: See Kuno, "Chōkoku" (note 4), p. 132. The provenance of the *Miroku* is unknown and, since both hands are later restorations, it is impossible to establish the original iconography of the image. See Hasegawa Makoto, "Miroku zazō," in Nara rokudaiji taikan kankōkai, ed., *Hōryū-ji III, Nara rokudaiji taikan* 3 (Tokyo, 1969), pp. 73–74.

6. The earliest extant works in lacquer in Japan are the *Ten Great Disciples of the Buddha* and *Eight Divine Protectors of the Buddhist Faith* in the collection of Kōfuku-ji which were completed in 734. These statues were commissioned by Empress Kōmyō as part of an extensive sculptural program to honor the spirit of her deceased mother. The last work that conforms technically to the definition of lacquer sculpture is the standing *Yakushi* in the Main Hall at Tōshōdai-ji. The discovery of coins, minted between 796 and 815, embedded into the left hand of the figure establishes it as dating subsequent to those years.

7. The famous Chinese Buddhist painter and sculptor Dai Kui (died 395) is recorded as having made five Buddhas out of lacquer. See Alexander Soper, *Literary Evidence for Early Buddhist Art in China* (Ascona, 1959), p. 20. For a list of Chinese lacquer statues, see Sherman E. Lee, "A Dry Lacquer Buddhist Image from T'ang China," *The Bulletin of the Cleveland Museum of Art* 71, 3 (Mar. 1984), pp. 98–99.

8. The description here of the hollow dry-lacquer technique has been adapted from Myōchin Tsuneo, "Tōshōdai-ji o shū toshita Tempyō chōkoku no kōzō," *Tōyō bijutsu*, Special Issue, *Nara jidai II* (Jan. 1933), pp. 35–36.

9. Although there are no records that explicitly mention the founding of the Office, documents do indicate that, late in the year 746, Kuninaka no Kimimaro (died 774), who was subsequently to direct the sculpting of the *Great Buddha*, was appointed to the position of Head of Buddhist Sculpture Production at Konkōmyō-ji, the predecessor of Tōdai-ji. By 748, Konkōmyo-ji had been renamed Tōdai-ji and the name of the Office for the Construction of Tōdai-ji appears in contemporary documents for the first time. See Tanaka Tsuguhito, "Zō Tōdai-ji shi zōbussho no hito kenkyū," *Nantō bukkyō* 40 (May 1978), pp. 63–77, chart p. 69.

10. The earliest such office seems to have been founded in the late sixth century to supervise the construction of Hōkō-ji (Asuka-dera). See Takeuchi Rizō, "Zō jishi no shakai keizai shiteki kōsatsu," in *Nihon jōdai ji-in keizaishi kenkyū* (Tokyo, 1934), pp. 4–6.

11. Takeuchi (note 10), p. 3.

12. Artists from the Office worked on statues at Koga-dera in Omi Province (747), Daian-ji (749), Hokke-ji (759), Chishiki-ji in Kawachi Province (c. 760), Ishiyama-in in Omi Province (761), and Shin Yakushi-ji (762). See Tanaka (note 9), pp. 77–79.

13. Tanaka (note 9) described the organization of the Office in great detail, pp. 67–77.

14. For example, documents in the Shōsō-in indicate that there were 121 painters and 52 woodworkers in the Office. However, although we know a great deal about the career of the sculptor of the *Great Buddha*, Kimimaro, we know essentially nothing about any other artists of the eighth century, an indication of the superior position of the sculptors in the capital. For data on the organization of the Workshop, see Shimizu Zenzō, "Zō Tōdai-ji shi ni okeru konin shoshiki ni tsuite," *Bukkyō geijutsu* 55 (Aug. 1964), pp. 42–53.

15. Homma (note 3), p. 18.

16. As cited by Homma (note 3), p. 17.

17. The date of this work remains the subject of considerable controversy, with some scholars dating the image to the 770s. Given the importance of the statue to the temple, the use of the hollow dry-lacquer technique, and the stylistic affinities with works produced during the previous decade, it seems likely that the statue was produced during Jian Zhen's lifetime.

18. The presence on the base of the image of the names of three men involved in the sculpting adds credence to this hypothesis. One, Nuribe Ototmaro, was a member of a hereditary family of lacquerers which, in all likelihood, was connected with Tōdai-ji. See Mōri Hisashi, "Rushana butsu zazō," *Tōshōdai-ji II, Nara rokudaiji taikan 13* (Tokyo, 1972), p. 22. Technically, the work is of considerable interest as well. In contrast to the relatively simple system of bracing that was employed on most hollow dry-lacquer works, the internal bracing system on this image is the most complicated known. Instead of the boards held in place by the vertical struts used on earlier works, the artist of the *Vairocana* constructed a complex inner frame which closely follows the interior contours and provides support for the monumental lacquer shell. The only other hollow dry-lacquer work of this period is the seated *Yakushi* in the West Octagonal Hall of Hōryū-ji, which is both technically and stylistically similar to the *Vairocana*. See Myōchin (note 8), pp. 36–38.

19. Although records indicate that sculptors accompanied Jian Zhen on at least one of his five failed trips to get to Japan, there is a disagreement as to whether or not artists were in his party when he finally arrived in the Nara capital in 754. The presence of so many works reflecting mid-eighth-century Chinese styles at Tōshōdai-ji is evidence that Chinese artists must have been with him. See Matsubara Saburō, "Ganjin tōrai to Tōshōdai-ji no butsuzō," in Kameda Tsutomu, ed., *Tōsei-den emaki, Nihon emakimono zenshū 21* (Tokyo, 1964), pp. 42–43.

20. For example, Jitchū (act. 752–807), the Intendent of Tōdai-ji, erected the mandorla for the *Great Buddha* in 763, a feat that Kimimaro had been unable to accomplish. He was also in charge of repairs to the Great Buddha Hall. See Matsubara Hironobu, "Jitchū oshō shoron," *Shoku nihongi kenkyū 177* (Feb. 1975), pp. 1–25.

21. Quoted in Fukuyama Toshio, "Nara jidai ni okeru Ishiyama-dera no zoei," *Nihon kenchikushi no kenkyū* (Tokyo, 1943), pp. 382–83.

22. Asaka Toshiki, *Nihon kodai shūkōgyō shi no kenkyū* (Tokyo, 1971), p. 389.

23. These studies were the work in the 1950s of Kuno Takeshi and, more recently, by a team headed by Honma Norio of Tokyo University of Arts. See Kuno, "Chōkoku" (note 4), pp. 123–41; and Honma Norio and Nishimura Kōchō, "X-sen ni yoru Shōrin-ji Jūichimen Kannon ryūzō no kōzō ni tsuite," *Tokyo geijutsu daigaku bijutsu gakubu kiyō 10* (1974), pp. 3–36; Honma Norio and Okabe Hiroshi, "Kōzan-ji Yakushi sanzon no kōzō ni tsuite," *Tokyo geijutsu daigaku bijutsu gakubu kiyō 12* (1977), pp. 45–104; Honma Norio, "X-sen ni yoru Nōman-ji Kokūzō bosatsu zazō oyobi Gakuan-ji Kokūzō bosatsu hanka zō no kenkyū," *Tokyo geijutsu daigaku bijutsu gakubu kiyō 15* (1980), pp. 33–70.

24. Kuno labeled this technique "wood skeleton core." For his discussion of the triad, see Kuno, "Chōkoku" (note 4), p. 125.

25. Only the main image remains in the possession of the temple today. The flanking statues of Nikkō and Gakkō are in the collections of the Tokyo National Museum and Tokyo University of Arts, respectively. Kuno first assigned the term "joined woodblock core" to this technique. For his discussion of the triad, see Kuno, "Chōkoku" (note 4), pp. 127–29.

26. For information on the thickness of the layer of lacquer, see Honma and Okabe, "Kōzan-ji" (note 23) chart 8, p. 98.

27. This work was originally in the temple connected to Omiwa Shrine in southern Nara and was moved to its present location in the late nineteenth century.

28. Honma and Nishimura, "X-sen ni yoru Shōrin-ji" (note 23), chart and figs. 20 and 21, p. 28.

29. Kuno identified a fourth group based on his analysis of a technique that uses multiple blocks that have not been hollowed. Representative statues include the *Four Deva Kings* in the North Octagonal Hall at Kōfuku-ji. Although important as the only dated works of wood-core dry-lacquer sculpture, this technical innovation is better viewed as a minor variation of joined wood-core. See Kuno, "Chōkoku" (note 4), pp. 132–35.

30. For a discussion of the *Monju*, see Hasegawa Makoto, "Monju zazō," *Yakushi-ji, Nara rokudaiji taikan 6* (Tokyo, 1970), pp. 70–71. For a discussion of the *Kokūzō*, see Nara kokuritsu hakubutsukan, ed., *Kokuhō jūyō bunkazai bukkyō bijutsu (Hokkaidō-Tōhoku)* (Tokyo, 1972), p. 94.

31. Tanabe, *Zaigai nihon no shihō* (note 4), p. 162. The methods of construction of the *Monju* and the *Miroku* have not been adequately analyzed.

32. The strength of the style can be seen in works as disparate as the *Bon-ten* in the Lecture Hall at Tō-ji (839), the *Amida* in the Main Hall at Kōryū-ji (c. 840), and the standing *Eleven-headed Kannon* at Dōgan-ji (c. 860).

A Spanish Pistol from the
French Royal Collection

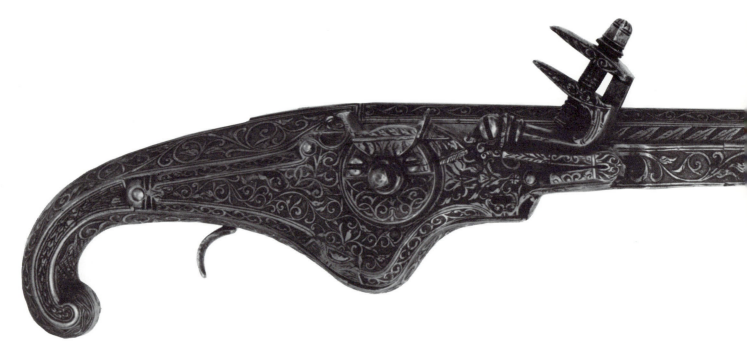

LEONID TARASSUK,
Consulting Curator of Arms and Armor

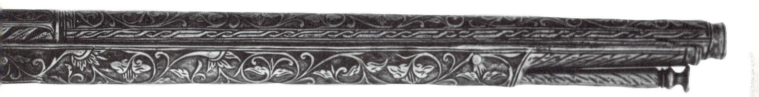

THROUGHOUT HISTORY, weapons and armor have been prized and collected for their craftsmanship, usefulness, and beauty. As tools of warfare and hunting or as ceremonial pieces, arms have reflected the power, wealth, and splendor of their owners. In 1982, The Art Institute of Chicago was fortunate to receive one of the largest and most important collections of arms and armor in the world. This outstanding assemblage comprises an extensive array of weapons and defensive gear—over 1,500 objects—from suits of armor and firearms to swords and daggers. Their dates and origins of manufacture range from the fifteenth through the nineteenth centuries and from Europe and the Middle East to the United States.

These holdings, now known as the George F. Harding Collection of Arms and Armor, came to the Art Institute from the former Harding Museum in Chicago. George F. Harding, Jr. (1868–1939), was a Chicago businessman who became interested in collecting arms early in this century. Many of the pieces he acquired came from the sale of great private collections in Europe after World War I. In 1927, to house his growing collection, he built a castlelike residence on his southside Chicago property; a few years after his death, it was opened to the public as a museum. When his house and castle were demolished in 1964–65, the collection was moved to a downtown Chicago location, where it remained until 1982, when the trustees of the Harding Museum selected the Art Institute as the collection's permanent home.

As so often occurs with great collections, a surprising and important discovery has recently been made in connection with an elaborately decorated wheellock pistol from the Harding Collection (fig. 1). Evidence has

FIGURE. 1. Spanish (Ripoll, Catalonia). *Wheellock Pistol*, c. 1600. Iron and wood; overall length 55.8 cm, barrel 43 cm; caliber 11 mm. The Art Institute of Chicago, George F. Harding Collection (no. 524) (1982.2304).

been found that places this superb object at one time in the *cabinet d'armes* (arms collection) of a great connoisseur and collector, King Louis XIII of France (reigned 1610–1643). The history of this pistol seems to be as full of adventure as the object is typologically rare and visually attractive. Made almost four centuries ago in Catalonia, Spain, it was somehow acquired by Louis XIII, but later disappeared in the turbulence of civil strife and military disasters. By the end of the nineteenth century, it had reappeared in the Saxon town of Grossenhain, not far from Dresden, in the possession of Richard Zschille, an arms collector. The pistol came to Chicago when his collection was shown in the "German Village" at the World's Columbian Exposition in 1893. Sold at a London auction four years later, when the Zschille Collection was dispersed, the pistol was subsequently acquired by George F. Harding and brought back to Chicago.[1]

On the pistol's only undecorated spot of metal surface, almost hidden behind the cock of the wheellock (see fig. 3), is engraved a number that for a long time has been read as "No. 215," and that was thought to refer to an inventory number of the Zschille Collection. However, the paleography of the numerals, strongly reminiscent of those found on firearms of Louis XIII, suggests that the pistol had indeed been part of the French royal arms

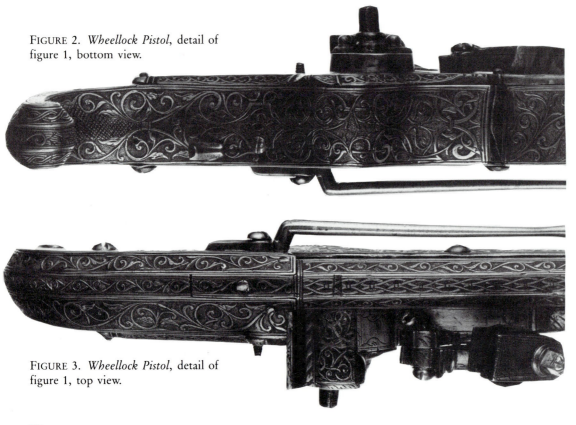

FIGURE 2. *Wheellock Pistol*, detail of figure 1, bottom view.

FIGURE 3. *Wheellock Pistol*, detail of figure 1, top view.

FIGURE. 4. Flemish, School of Rubens. *King Louis XIII of France Crowned by Victory*, c. 1615. Oil on canvas. H. M. Tower of London. Reproduced by permission of the Master of the Armouries.

collection. This suggestion remained but a tempting hypothesis until further research produced new information about the pistol.

The Dauphin Louis, son of King Henry IV of France and Navarre and Marie de Medicis, became fascinated with weapons and armor at a very early age. Born on September 7, 1601, the boy had already displayed an interest in firearms by his third birthday, when he received as gifts his first *arquebus* (a type of gun) and a bandolier with cartridge holders. According to contemporary accounts, his interest exceeded the common and fleeting boyish attraction to things military and developed into a steady and serious hobby. By the age of ten, soon after having been proclaimed King Louis XIII (1610), he already possessed at least seven guns, which he used for hunting and target shooting. During the next three years, the king's collection increased to some forty pieces, while his interest gradually expanded to encompass not only ordinary firearms for current use, but also various pieces of arms and armor of historical, structural, and artistic value.[2]

The king's passion for arms and armor is reflected in a painting of around 1615 showing the adolescent ruler as a military commander (fig. 4). He is depicted wearing a half-armor, with a dagger attached behind at the waistbelt in contemporary fashion, a sword in his left hand, and a commander's staff in the right. At the king's feet is an array of various objects, most likely all from his own collection: a round shield and elements of armor; a riding sword whose pommel form matches that of the dagger Louis is wearing. There are also three pairs of wheellock pistols: a pair of splendid, gold-decorated French pistols; simpler, military-type holster pistols that are probably Flemish or French; and small, all-metal belt pistols—already antiquarian pieces at the time the king posed for this portrait, since they had been made in Germany at least ten years before his birth.

Louis XIII's passion for arms collecting never diminished; he continued to acquire fine and interesting pieces made in France and abroad—including those of eastern European and oriental origin. One of the king's favorite pastimes was examining, cleaning, and assembling firearms in the quiet of his *cabinet* at the Louvre. He also enjoyed showing off his collection to others who could appreciate such objects. So well known was his preoccupation that it won him the nickname "Louis *l'Arquebusier.*" About four years before his death in 1643, the king casually mentioned to the ambassador of Venice that he had more than 200 firearms in his *cabinet d'armes.*[3]

That this was a very modest estimate of his favorite treasures is shown by the existing inventories of the royal collection, first catalogued during the reign of Louis XIV (1643–1715), and basically completed on February 20, 1673.[4] With two small, later supplements, the inventory includes 351 entries, recording more than 700 objects (some entries describe two or more items of

identical design or similar type, such as a pair of pistols or a group of pikes). Of this impressive total, about 500 objects were firearms, many of them significant for their construction, decoration, or rarity.

The four decades of Louis XIII's collecting coincided with a remarkable period in the history of arms and armor, particularly in the development of firearms. Numerous workshops in various European countries were producing deluxe weapons combining outstanding structural features and magnificent decoration. It was at this time that French craftsmen began to assume the lead in this domain; a select group of gunmakers and decorators enjoyed a highly privileged status at the royal court, where they were granted living quarters and workshops in the Louvre. It was during Louis XIII's reign that gunmakers developed the flintlock of French construction—the ultimate spark-producing ignition mechanism that was destined to dominate in European (and, later, American) hand firearms for about 200 years. Initially applied most to custom-made, civilian firearms and soon, increasingly, to mass-produced military guns and pistols, the French flintlock was simpler, cheaper, and more reliable than previous systems of automatic ignition (like the wheellock or snaphance). Because the flintlock's development both widened the use and upgraded the performance of firearms, it significantly affected military tactics as well as certain aspects of social life (hunting, etc.). These circumstances certainly contributed to the growth of the royal collection, which was expanded to include, along with simple firearms and other weapons for hunting or martial exercises, many valuable objects with innovative technical features and of different national styles, as well as superbly decorated pieces presented to or commissioned by the king.

Louis XIII's successors continued to augment his *cabinet d'armes* with their personal arms and historic relics. The 1717 inventory of the royal collection, with a minor supplement of 1738, contains 458 entries covering nearly 850 objects and shows the extent to which the collection had grown.[5] The last inventory of the collection was produced in 1775, when 31 more entries were added to the previous catalogue, resulting in a total of 489 entries recording almost 900 pieces.[6]

Along with other royal property, the arms collection suffered heavy losses from displacements and pillages during the revolution of 1789, the occupation of Paris in 1815, and the 1830 uprising. Although several dozen objects later emerged in French and foreign museums and private collections, the *cabinet d'armes* as an organized and preserved collection ceased to exist. Nonetheless, students of arms, armor, and decorative arts never lost their deep interest in this remarkable, historic collection, nor did they halt attempts to locate and identify its contents. As a rule, inventory numbers had been stamped or engraved on the objects, a practice introduced by the first cataloguers and continued by their successors. In the instances where, for some reason, this was not done, the unmarked objects can often be identified by comparing them with the more-or-less detailed descriptions and measurements given in the inventories. In 1939, only 77 items had been positively identified;[7] by 1965, the group had increased to 108.[8] Twelve new objects had been identified by 1978,[9] and now at least ten more objects can

be added to the list of extant pieces from the original *cabinet d'armes*.[10] The wheellock pistol acquired by the Art Institute is the latest discovery of this kind.

The first attempt to find the description of this pistol in the inventory of the French royal arms collection resulted in disappointment. The inventory entry for no. 215, which describes a pair of pistols, did not correspond at all to the Harding pistol. However, closer study of the firearm itself revealed that the middle numeral of the marking had been somewhat obliterated by excessive cleaning, thus concealing the actual number, 245.

In the 1673 inventory of the *cabinet d'armes* are the following entries:

"[No.] 244—Another wheellock pistol, in Spanish style, 26 *pouces* [long], [barrel] round in front, with eight facets in the rear, chiseled in relief in three places; the wheel[lock] decorated in same manner [; mounted] on wooden stock engraved and ornamented with several iron sheets.

[No.] 245—Another, [but] smaller, pistol, 20 *pouces* [long], nearly similar to the preceding."[11]

It seems likely that the earliest extant inventory of the arms collection was based not only on actual physical examination of the objects being described, but also on some earlier records that included notes on their provenance. This is borne out by the fact that these descriptions from the 1673 manuscript pinpoint the national origin of these two pieces, and are accurate about other details, as well.

There is little doubt that the authors of the second inventory, which was drawn up in 1717 after the death of Louis XIV, were guided to a considerable extent by the catalogue compiled by their predecessors. This inventory follows the sequence of entries already established, actually repeating, in different wording and with some amendments, the earlier descriptions.[12] The last inventory (1775), also undertaken after a new succession to the French throne, follows entries in the older documents but is more economical in its descriptions, omitting whatever the cataloguers deemed unessential for purposes of identification.[13]

In all the inventories, the length of pistol no. 245 was recorded as 20 *pouces*. The *pouce* (thumb), one-twelfth of a *pied* (foot), was a measure of length equivalent to 2.707 cm, or 1 1/16 inches. A length of 20 *pouces* is the equivalent of 54 cm (21 5/16 in.), which means that the difference in length between the Harding pistol and the description of item no. 245 of the *cabinet d'armes* is a mere 1.7 cm (11/16 in.). Considering the approximations practiced by the cataloguers, who commonly rounded off lengths to the nearest *pouce*, this difference is almost negligible, and it can be safely assumed that the three inventories quite accurately describe the Art Institute pistol.

The general form, construction, and decoration of this specimen are typical of the long pistols (*pedrenyales*) made in Catalonia in the late sixteenth and early seventeenth centuries.[14] The distinctive, and apparently unique, peculiarity of the pistol is its gracefully curled grip (see fig. 5), which is not fitted with a pommel and is very small, even by standards favored in Catalonian pistols. Other pistols made there have a short grip terminating in a ball-

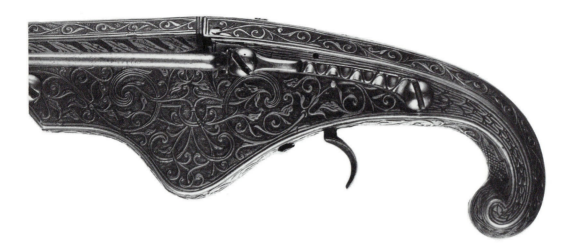

FIGURE 5. *Wheellock Pistol*, detail of figure 1, left side, showing belt hook.

shaped pommel or one of the so-called fishtail form. The handling of such pistols was considerably facilitated by a spur for the middle finger on the trigger-guard (now missing on this pistol) [15] The inconvenience of a small grip was compensated for when one was able to carry several such pistols either at the belt, or up to five of them in a special open holster or *xarpa* worn across the breast, like a *baldric* or bandolier. [16] This could have provided a significant advantage, since most firearms at this time had to be reloaded after each shot. An iron ramrod to load the pistol is incised on both ends with diagonal strokes for better handling and has a baluster-shaped tip.

The two-stage barrel of the Art Institute pistol is octagonal in the rear two-fifths, with a molding on each end of the round section. The tang screw, which attached the barrel breech to the stock, has been replaced by a modern part since the lost original screw must have been brazed to the front of the missing trigger guard. The wooden stock is completely encased in sheet iron incised with linear borders and profusely chiseled in relief with floral scrolls and other stylized foliage matching the similar decoration on the barrel and lock. On the left side of the stock (see figs. 2, 3, 5), a long belt hook is held in place by the central and rear side-screws of the lock, the tail of the hook being partly sunk in a cut-out made in the sheath.

The wheellock (see figs. 6, 7) is of an early type, with no safety catch; the wheel is completely covered by the housing. The convex, pivoted pan-cover moving around the wheel has a stabilizing arm sliding on the lock plate and a small thumbpiece symmetrical with the flash fence of the pan. This design is practically identical to the pan-cover construction in some contemporary French wheellock pistols. The lower branch of the cock spring is half as long as the upper one, like the cock spring in some of the earliest German wheellock mechanisms. Some interior parts of the mechanism [17]—the main spring, its bridle, and the sear—are slightly ornamented with chiseled scrolls and lines. On the frontal base of the bridle (see fig. 6), the ornament forms a distinctive capital *M*, perhaps the lock maker's initial (it is tempting to identify him as one of several gunmakers, such as Mas or Molas, recorded in Ripoll, a small town in the Pyrenees[18]).

This pistol is but one of the interesting objects in the George F. Harding Collection of Arms and Armor, and there remain a substantial number that bear as yet unidentified heraldic devices, makers' marks, emblems, and nu-

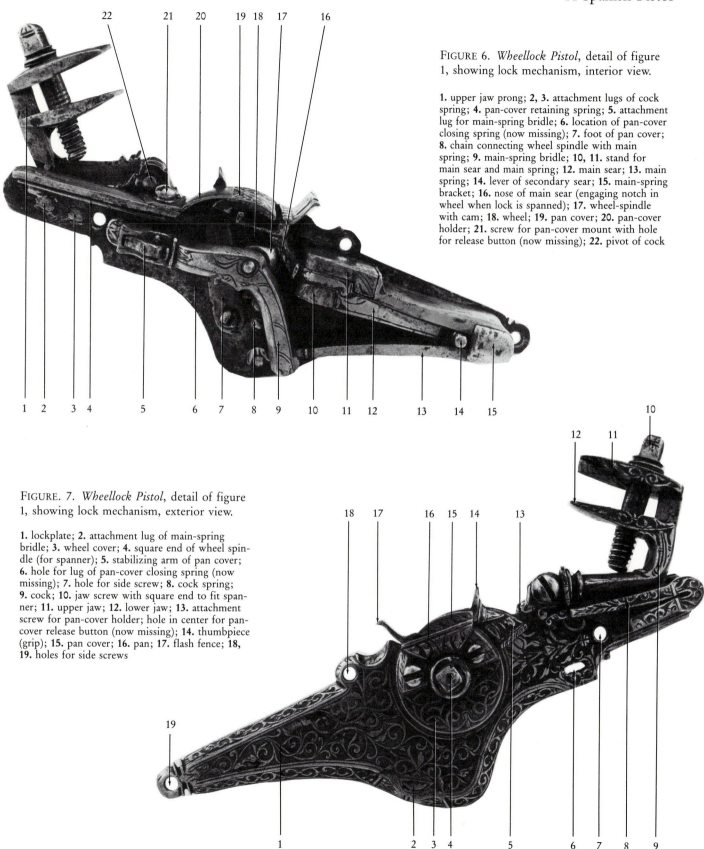

FIGURE 6. *Wheellock Pistol*, detail of figure 1, showing lock mechanism, interior view.

1. upper jaw prong; 2, 3. attachment lugs of cock spring; 4. pan-cover retaining spring; 5. attachment lug for main-spring bridle; 6. location of pan-cover closing spring (now missing); 7. foot of pan cover; 8. chain connecting wheel spindle with main spring; 9. main-spring bridle; 10, 11. stand for main sear and main spring; 12. main sear; 13. main spring; 14. lever of secondary sear; 15. main-spring bracket; 16. nose of main sear (engaging notch in wheel when lock is spanned); 17. wheel-spindle with cam; 18. wheel; 19. pan cover; 20. pan-cover holder; 21. screw for pan-cover mount with hole for release button (now missing); 22. pivot of cock

FIGURE. 7. *Wheellock Pistol*, detail of figure 1, showing lock mechanism, exterior view.

1. lockplate; 2. attachment lug of main-spring bridle; 3. wheel cover; 4. square end of wheel spindle (for spanner); 5. stabilizing arm of pan cover; 6. hole for lug of pan-cover closing spring (now missing); 7. hole for side screw; 8. cock spring; 9. cock; 10. jaw screw with square end to fit spanner; 11. upper jaw; 12. lower jaw; 13. attachment screw for pan-cover holder; hole in center for pan-cover release button (now missing); 14. thumbpiece (grip); 15. pan cover; 16. pan; 17. flash fence; 18, 19. holes for side screws

merals. Certainly, from among those that are still to be investigated, there are more important and surprising discoveries like the Spanish pistol from the French royal collection. Further study of these objects may well bring to light new and fascinating information about the origin and provenance of weapons and armor at The Art Institute of Chicago.

NOTES

1. See R. Forrer, *Die Waffensammlung des Herrn Stadtrath Rich. Zschille* (Berlin, [1894]), p. 28, inv. no. 1047, pls. 215–17, 220. According to MS notes on the Harding Collection by S. V. Grancsay, the pistol was acquired from a London dealer, Hal Furmage (no date cited). Apparently, it is this pistol that is described in London, Christie, Manson and Woods, *Catalogue of the Collection of Armour and Arms and Hunting Equipment of Herr Richard Zschille, of Grossenhain* (sale cat., Jan. 25 and Feb. 1, 1897), p. 19, lot 87 ("A Wheel-lock Pistol, partly octagonal barrel—17 *in. long*—faceted steel stock and wheel lock, the whole barrel, lock and stock chased in relief with interlaced floral scrolls and arabesques—end of 17th century"). The title page states that the collection described therein had been exhibited at the World's Columbian Exposition in Chicago (1893). In the catalogue published on that occasion, there is indeed a direct reference to the pistol in question: see the *Catalogue of the Collection in the Museum of the "Wasserburg"* ["German Village"], Columbian-World-Exposition at Chicago, 1893, p. 21 ("1047 Radschlosspistole [Wheel-lock pistol], mit reichem Eisenschnitt und Eisenschaeftung, um 1600").

2. On the history of the French royal arms collection, see: J. F. Hayward, "Notes on the Cabinet d'armes of Louis XIII," *Livrustkammaren* 13, 1 (1973), pp. 23–31; idem, "Further Notes on the Invention of the Flintlock," in *Art, Arms and Armour*, ed. R. Held (Chiasso, Switzerland, 1979), pp. 238–51; J. P. Reverseau, "Les Armures des rois de France au Musée de l'Armée. Origine et provenance," *VIII Congress of the International Association of Museums of Arms and Military History* (Warsaw/Cracow, 1978), pp. 153–60.

3. M. Morin and R. Held, ". . . And His Majesty Said, 'all my guns together are not worth one of these,' " *Art, Arms and Armour* (note 2), pp. 268–69, 277.

4. J. Guiffrey, "Armes et armures de diverses sortes," pt. 2 of *Inventaire général du mobilier de la couronne sous Louis XIV (1643–1715)* (Paris, 1886), pp. 43–84.

5. S. V. Grancsay, *Master French Gunsmiths' Designs* (New York, 1970), pp. 185–208; text of the chapter "Armes et armures" in the *Inventaire général du mobilier de la couronne*, a manuscript of the 1717 inventory preserved in the Archives Nationales, Paris; A.V.B. Norman, "Arms and Armour in the Journal du Garde-Meuble de la Couronne," *The Journal of the Arms and Armour Society* 9, 5 (June 1979), pp. 187–94.

6. See Norman (note 5). The 1775 inventory has not yet been published. Two manuscript copies of this document are preserved in the Archives Nationales, Paris, ref. nos. O′3349 and O′3350. See also note 13.

7. T. Lenk, *Flintlåset, dess uppkomst och utveckling* (Stockholm, 1939), App. I, pp. 184–85.

8. T. Lenk, *The Flintlock; its origin and development*, ed. J. H. Hayward (London, 1965), App. I, pp. 167–77.

9. Reverseau (note 2), pp. 156–58.

10. These recently identified objects are discussed by the author in "The Cabinet d'armes of Louis XIII: Some Firearms and Related Problems," *Metropolitan Museum Journal* 21 (1986), pp. 65–122.

11. Guiffrey (note 4), p. 75 (author's translation). The original text is as follows: "[No.] 244—Un autre pistolet à roüet, à l'espagnol, de 26 pouces, rond sur le devant, à huit pans sur le derrière, gravé en taille d'espargne en trois endroits: le roüet ouvragé de mesme sur un bois gravé et orné de quelques plaques de fer. [No.] 245—Un autre plus petit pistolet, de 20 pouces, pareil à peu près au précédent."

12. Grancsay (note 5), p. 198 (author's translation): "[No.] 244—A pistol with wheellock and in Spanish style, twenty-six *pouces* long, mounted on a wooden stock carved and decorated with chiseled iron sheets; the barrel with eight facets on the breech, chiseled in three places, the wheel[lock] decorated in same manner. [No.] 245—Another pistol similar to the preceding, except that its length is only twenty *pouces*."

13. Archives Nationales, Paris, ref. no. 0'3349, fol. 302 (author's translation): "[No.] 244—A pistol, twenty-six *pouces* long, mounted on a carved wooden stock decorated with chiseled iron sheets; the barrel with eight facets on the breech, chiseled in three places; the wheellock decorated in same manner. [No.] 245—Another pistol similar to the preceding, except that it is only twenty *pouces* long." Another manuscript copy of the 1775 inventory, written in different handwriting and with different spelling and punctuation, gives exactly the same description of these two objects (ref. no. 0'3350, fol. 156).

14. Catalonian firearms, including those made in the town of Ripoll, are discussed in: J. D. Lavin, *A History of Spanish Firearms* (London, 1965), pp. 218–19; idem., "Spanish Agujeta-Lock Firearms," in *Art, Arms and Armour* (note 2), pp. 298–313; E. Graells, *Les Armes de foc de Ripoll* (Ripoll, 1974). Idem. "A Primer of Ripoll Gunlocks," *Arms and Armor Annual* 1, ed. R. Held (Northfield, Illinois, 1973), pp. 129–41; only nine specimens of Catalonian wheellock pistols are listed; to these can be added the Chicago pistol and a pair of pistols at the Hermitage Museum, Leningrad (see L. Tarassuk, *Antique European and American Firearms at the Hermitage Museum* [Leningrad, 1971], nos. 67, 68).

15. The illustrations of the pistol in Forrer's catalogue (note 1) show that the trigger guard with tang screw, the pan-cover closing spring, and the release button had been already lost by the time of publication.

16. Lavin, *A History of Spanish Firearms* (note 14), p. 235, pl. 121 (illustrated here is a *xarpa* in the collection of The Metropolitan Museum of Art, New York, acc. no. 14.25.1246).

17. See figs. 6 and 7 for identification of specific parts. Below the cock, in the lock plate, is a small rectangular slot to fit the lug of the pan-cover closing spring (now missing), which was installed inside the mechanism. When opened by the wheel-spindle cam, the pan-cover was retained in this position by a hooked catch-spring screwed inside the plate. To close the pan-cover, the retaining spring was pressed by means of a release button in front of the pan (the button has been lost but an aperture for its stem can be seen in the center of the screw head on the pan-cover mount). The upper jaw of the cock is forged with a directional prong fitting a slot in the lower jaw. To grasp the pyrite (the spark-producing stone) more firmly, the inner surfaces of the jaws are roughly incised with four concentric squares twice crossed diagonally. Compared with good-quality European locks, the workmanship of this mechanism appears somewhat crude: although it may have functioned quite well, some priming powder must inevitably have fallen inside the lock through the fairly wide clearance between the wheel ridges and the corresponding indentations in the pan, which probably were simply filed out and not precision milled.

18. Graells, *Les Armes de foc de Ripoll* (note 14), p. 164.